SECRETS TO REALISTIC DRAWING

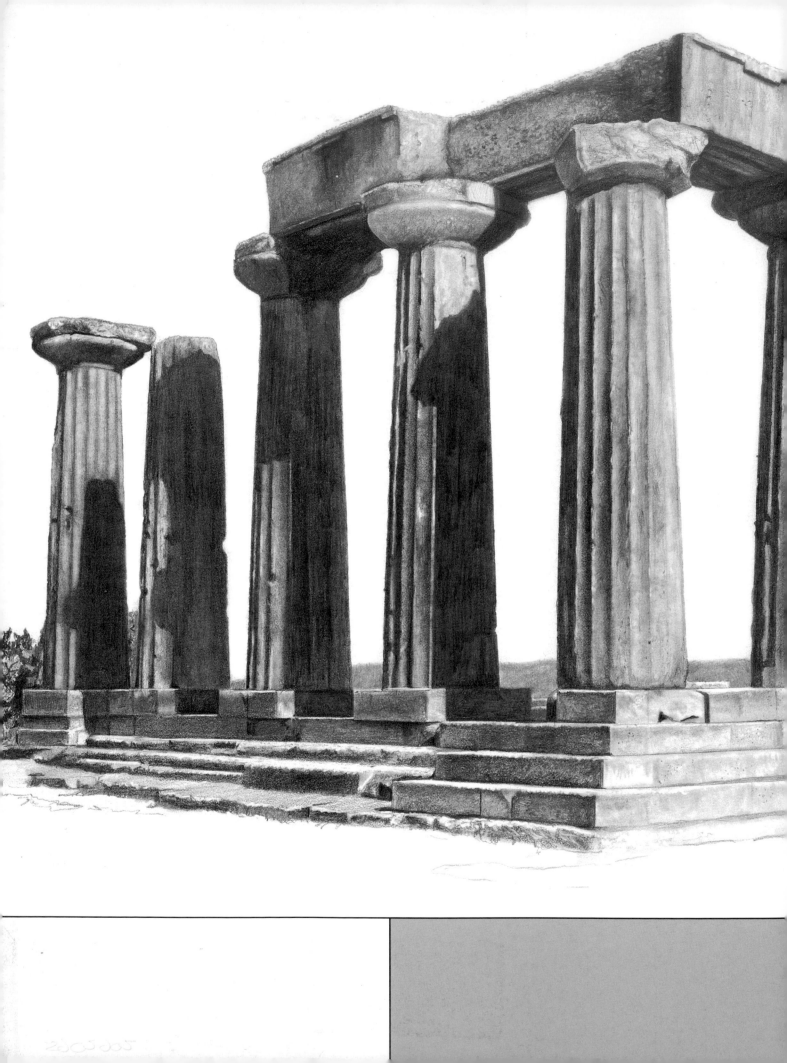

secrets to REALISTIC DRAWING

CARRIE STUART PARKS & RICK PARKS

NORTH LIGHT BOOKS
CINCINNATI, OHIO
www.artistsnetwork.com

ABOUT THE AUTHORS

Carrie Stuart Parks and Rick Parks met in the romantic hallways of the FBI Academy in Quantico, Virginia. They married in 1989 and formed a dynamic and successful team in their forensic and fine art endeavors, developing composite drawings of suspects in major national and international cases, as well as creating exquisite watercolors and stone carvings. They travel across the United States and internationally to teach one-week composite drawing courses to a variety of participants, from large law-enforcement agencies to small, two-person police departments, from Secret Service and FBI agents to interested civilians.

Carrie has won numerous awards for her innovative teaching methods and general career excellence and is a signature member of the Idaho Watercolor Society. She is the author and illustrator of *Secrets to Drawing Realistic Faces* (North Light Books, 2003). Rick has received national recognition for his exquisite art placed on musical instruments.

Carrie and Rick reside in North Idaho and may be contacted through their Web site at www.stuartparks.com or by e-mail at carrie@stuartparks.com.

Page 2–3 art:

CORINTH, GREECE
14" x 17" (36cm x 43cm) Graphite on bristol board

Other fine North Light Books are available from your local bookstore, art supply store or direct from the publisher.

DISTRIBUTED IN CANADA BY FRASER DIRECT
100 Armstrong Avenue
Georgetown, ON, Canada L7G 5S4
Tel: (905) 877-4411

DISTRIBUTED IN THE U.K. AND EUROPE BY DAVID & CHARLES
Brunel House, Newton Abbot, Devon, TQ12 4PU, England
Tel: (+44) 1626 323200, Fax: (+44) 1626 323319
E-mail: mail@davidandcharles.co.uk

DISTRIBUTED IN AUSTRALIA BY CAPRICORN LINK
P.O. Box 704, S. Windsor NSW, 2756 Australia
Tel: (02) 4577-3555

10 09 08 07 06 5 4 3 2 1

Library of Congress Cataloging in Publication Data
Parks, Carrie.
 Secrets to realistic drawing / by Carrie Stuart Parks and Rick Parks.
 p. cm.
 Includes index.
 ISBN 1-58180-649-3 (alk. paper)
 1. Drawing--Technique. I. Parks, Rick. II. Title.

NC730.P25 2006
741.2--dc22 2005012853

Editors: Layne Vanover and Stefanie Laufersweiler
Production editor: Erin Nevius
Cover designer: Wendy Dunning
Interior design and production artist: Barb Matulionis
Production coordinator: Mark Griffin

Metric Conversion Chart

to convert	to	multiply by
Inches	Centimeters	2.54
Centimeters	Inches	0.4
Feet	Centimeters	30.5
Centimeters	Feet	0.03
Yards	Meters	0.9
Meters	Yards	1.1
Sq. Inches	Sq. Centimeters	6.45
Sq. Centimeters	Sq. Inches	0.16
Sq. Feet	Sq. Meters	0.09
Sq. Meters	Sq. Feet	10.8
Sq. Yards	Sq. Meters	0.8
Sq. Meters	Sq. Yards	1.2
Pounds	Kilograms	0.45
Kilograms	Pounds	2.2
Ounces	Grams	28.3
Grams	Ounces	0.035

DEDICATION

In Virginia in the early 1960s, my mother watched as I started drawing the world around me. She saw not only my love of art but also an ability to excel in it. For the rest of her life she offered constant encouragement and, more importantly, she never discouraged me in my dream of becoming an artist.

It's because of her that I used my art on some of America's biggest cases, taught thousands of others to draw and helped to produce the book you now hold in your hand. Her example of encouragement to me as an artist is the most important lesson in this book. God bless you, Mom.

—Rick Parks

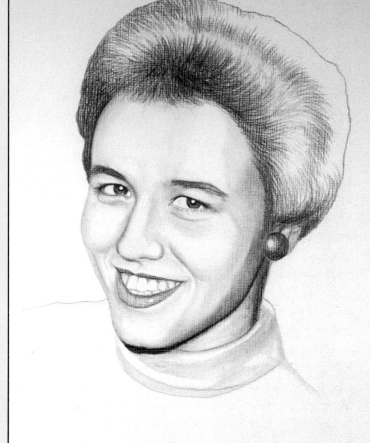

SHIRLEY
Graphite on Crescent Lin-Tex board
12" x 9" (30cm x 23cm)
Dedicated to the memory of Shirley Marcey Parks

ACKNOWLEDGMENTS

This book started out so well, but Rick and I ended up with a monster of a year. We'd like to gratefully thank the fine folks at North Light Books who were so gracious when we needed it most. Thank you, Pam Wissman, for your wisdom in getting our book proposal through the proposal committee. Thanks to Bethe Ferguson for your support and encouragement. Thank you, Layne Vanover, for the most difficult work of initial editing. A very special thanks and a bottle of *something* to Stef Laufersweiler, who gave up a portion of her life to bring in this book and edit it so very well.

The people featured in the book deserve a hug and thanks: my brother Scott Stuart, Ethan Stuart, and Pastor Ashley Day and his lovely wife, Edna.

A big frog sticker goes to our students who so generously contributed their work: John Hinds, Sheila Tajima-Shadle, Greg Bean, Ken MacMillian and Matt Tucker. If you are interested in their work or prints, contact us through our Web site at www.stuartparks.com.

We had so many people who were with us in heart, body and spirit this year that it would take the rest of the book to thank them. We'd like to single out a few and give them a special note of gratitude: my Art Camp ladies, Mary Ellen, Brenda, Toni, Marilyn, Judy, Pat, Elvie, Debby and, of course, Miss Penny; hugs and thanks to Evelyn, Ron and Gina Prindle, Lori Bishop and Debs Laird; lunch and a hug to Shane and Merlin Berger, Frame of Mind Gallery.

Rick would personally like to thank Dan Fleshman, his high school art teacher who told him that he could make art a career if he tried when others said he couldn't. Thanks to Horace Heafner who, as his mentor, provided Rick with the ultimate example of a professional artist and a Christian gentleman. Many thanks to Bill Emerson, who allowed one of his biggest fans to grace his musical endeavors with his art. Love and thanks to Don Parks, who for nearly fifty years has continued to teach him the meaning of strength, determination and hard work: "You're my hero, Dad."

As always, eternal thanks, a world of love and a big noogie to Frank and Barbara Peretti. Finally, and most importantly, thank you to our Lord and Savior, Jesus Christ.

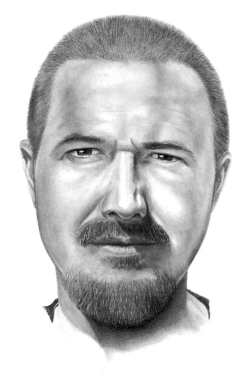

TABLE OF CONTENTS

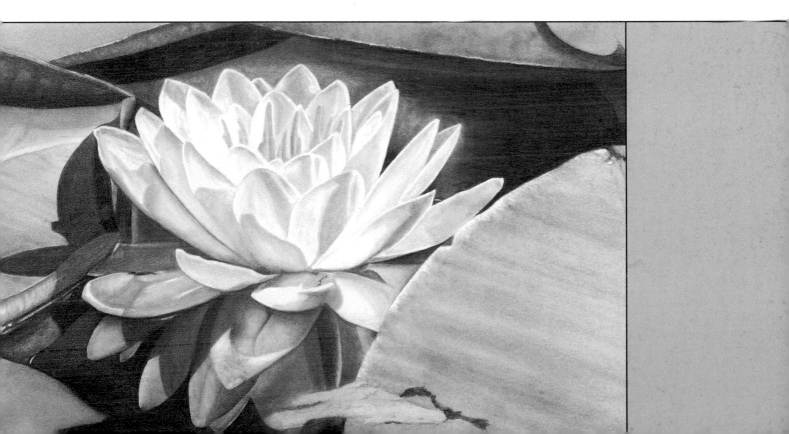

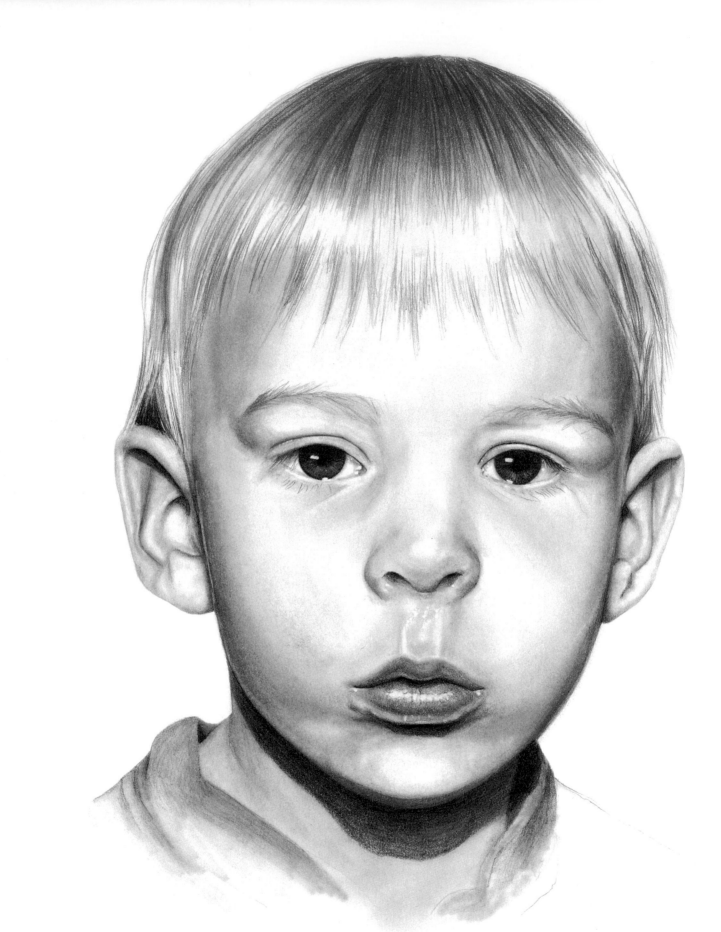

ETHAN STUART
Graphite on bristol board
17" x 14" (43cm x 36cm)

INTRODUCTION

So many times I have heard someone throw down the sword—make that the pencil—and issue this challenge to me: "Yeah, but you can't teach ME to draw!" Yes, I can teach you to draw, even if you can't draw a straight line—or draw blood with a knife. You're reading this book, which means you've met the only criteria I have: a desire to learn.

Drawing is a very learnable skill. If you haven't learned to draw, your drawings are weak or some art teacher told you to take up knitting instead, you just haven't had the right instruction. I'm not promising that you'll become Leonardo da Vinci by the end of this book, but I do believe you will draw better than you have ever hoped. All you must do is apply (and prac-

tice!) the drawing tools taught in this book. You'll soon discover that learning to draw is less about talent and more about learning to perceive the world around you differently.

Getting There

My own artistic journey is just colorful enough to make for a good, and hopefully inspirational, story.

I'd always found certain types of art easy. That is, I could look at some things and somehow draw them fairly accurately. I grew up in a small mining town in northern Idaho where the public school system could barely afford textbooks, let alone an arts curriculum. My parents did the best they could to encourage my talent, but when I announced that I was

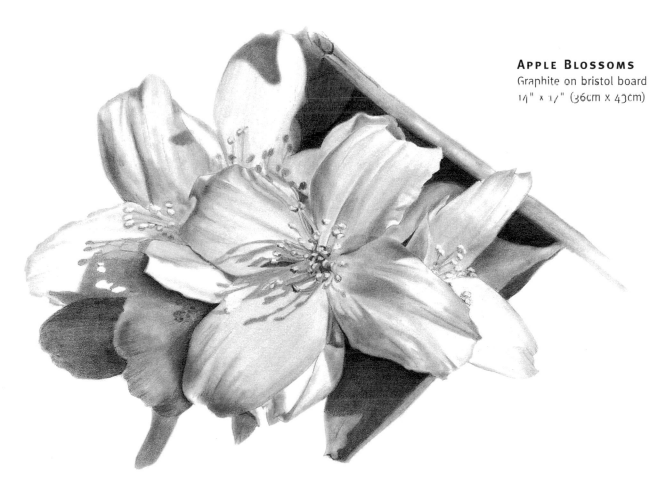

APPLE BLOSSOMS
Graphite on bristol board
14" x 17" (36cm x 43cm)

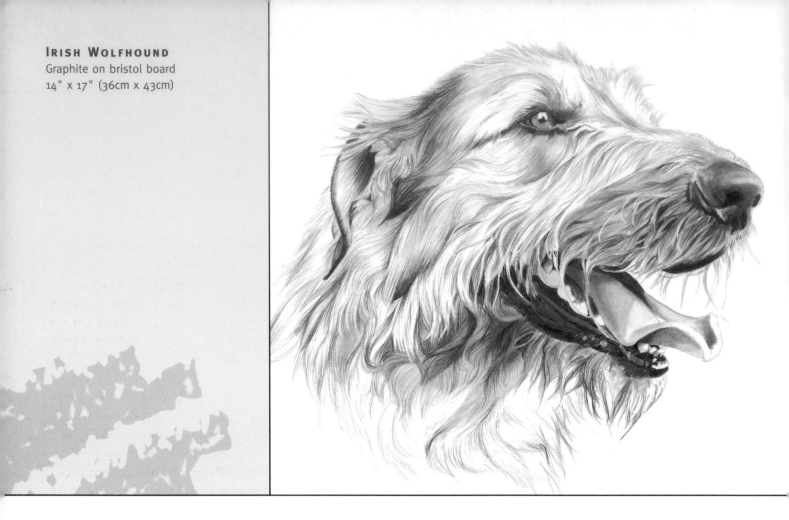

going to be a professional artist, they could barely mask their horror. Art was fine as a hobby, but a career? After much soul-searching, they bravely sent me off to a nearby community college to study commercial art.

I soon found myself floundering. Lessons consisted of the professors placing a mess of white shapes on a table and having us draw them. White balls, white shoes, white drapery and, well, more white stuff. I could never figure out the point. What is so special about white? Then we got to paint. We did paintings of the white stuff in the primary colors of red, blue and yellow. Egads! I just wanted to draw something that really *looked* like something.

After a year of not getting it, I changed majors and figured my art career was probably going to become a hobby after all. I envisioned myself as a gray-haired lady puttering with

bad oil paints on Saturday mornings. For several years I drifted from college to college and major to major. I became the consummate professional student.

Then one day I attended a gallery opening of watercolor paintings. As I wandered around the room studying the paintings, it hit me: I can do this! I can paint at least this well. So what was the difference between this artist and me? How did she get her own art show and not me? My husband dryly provided the answer: "She *did* it." She took the time and effort to actually create enough art for a one-woman show. I made up my mind then and there that I was going to be an artist, too, despite my collegiate setbacks.

The Story Continues

After some time as a watercolorist, I found myself developing a fascinating use for my drawing skills: I started

working at a crime lab as a forensic artist. Part of my job was sketching crime scenes. I would love to tell you that I was originally hired to work there because I was a brilliant artist with the crime-solving ability of Sherlock Holmes, but that would be stretching it. In 1985, I attended a short course on composite drawing at the FBI Academy in Quantico, Virginia. Composite drawings are the "Wanted" drawings you see of criminal suspects on the nightly news. They are usually created by combining separate facial features that the victim or witness of a crime selects from a book of faces. The composite is used to identify an unknown suspect. I was invited to the course only because the FBI wanted participants from a variety of regions throughout the United States. My face-drawing skills were still dreadful at this point, but I was inspired to improve.

I worked hard and paid attention to what it would take to do a good job. I became Carrie Parks, Pencil Sleuth. I loved drawing faces and became addicted to forensic art. I finally finished my college degree with a double major in social science and art—with honors, no less. My motto was, "I have a pencil, and I'm not afraid to use it!"

Now my husband and I travel across the nation teaching composite drawing and forensic art courses. We have taught all kinds of people of varying skill levels, from FBI and Secret Service agents to civilian adults and children. We have won awards for our teaching methods, and I've even written a book exclusively on drawing faces. And to think, at one point I thought art could only be a hobby!

So, the Point of This Is …

You, too, can realize your dream of becoming an artist if you set your mind to it. This book aims to teach you what it takes to do just that. I'm not going to set a bunch of stuff in front of you and expect miracles. Instead, I'll cover all the essentials, teaching you the secrets of realistic drawing one step at a time. Before you know it, you'll be turning out picturesque landscapes, stellar portraits—any subject that you like!

In my many years of teaching art, I've discovered that there are certain characteristics that define success as an artist. My short list is as follows:

Desire. Desire doesn't just mean wanting something, but wanting it badly enough that you're willing to try a different approach to get it. At first, you might not like it, might not do well trying it, or might not find it useful, but still you are willing to try. This characteristic is what will allow you to grow and improve your artistic skills.

Interest. It's hard to whip up a fascination for drawing Harley-Davidson motorcycles when you love to ride horses. You need to draw what interests you, and practice your drawing on the things that interest you.

Good instruction. This is my role. Good instruction is not up to the student, it is up to the teacher. If you've ever taken a class where you were told to draw something in a particular way but were never told why or how, you haven't failed—your teacher has.

If it's meaningless to you, you'll never learn. Art needs to be stepped out, explained and demonstrated. If it were as simple as just drawing something, you would already be doing it!

Focus. The artists who develop the best drawing skills usually have the best observational skills. This means having an eye for the details as well as the overall picture. This takes concentration and training but is well worth the effort.

Practice. To be good at anything, you need practice. One of my students was so thrilled by his new skills that he started drawing everybody, everywhere. I believe he had a sketchbook firmly in hand wherever he went. Of course, he is a fantastic artist now because he practiced his skill.

Talent. Some artists may have it, but you *don't* have to have natural talent to draw well. In my opinion, it takes far more training and skill development than actual talent to become a successful artist. Anyone can learn to draw by applying her desire and interest. I'll supply the good instruction if you focus on and practice what you're learning. Everyone will then be convinced that you had talent all along!

Carrie Stuart Parks

SWORD
Graphite on bristol board
14" x 17" (36cm x 43cm)

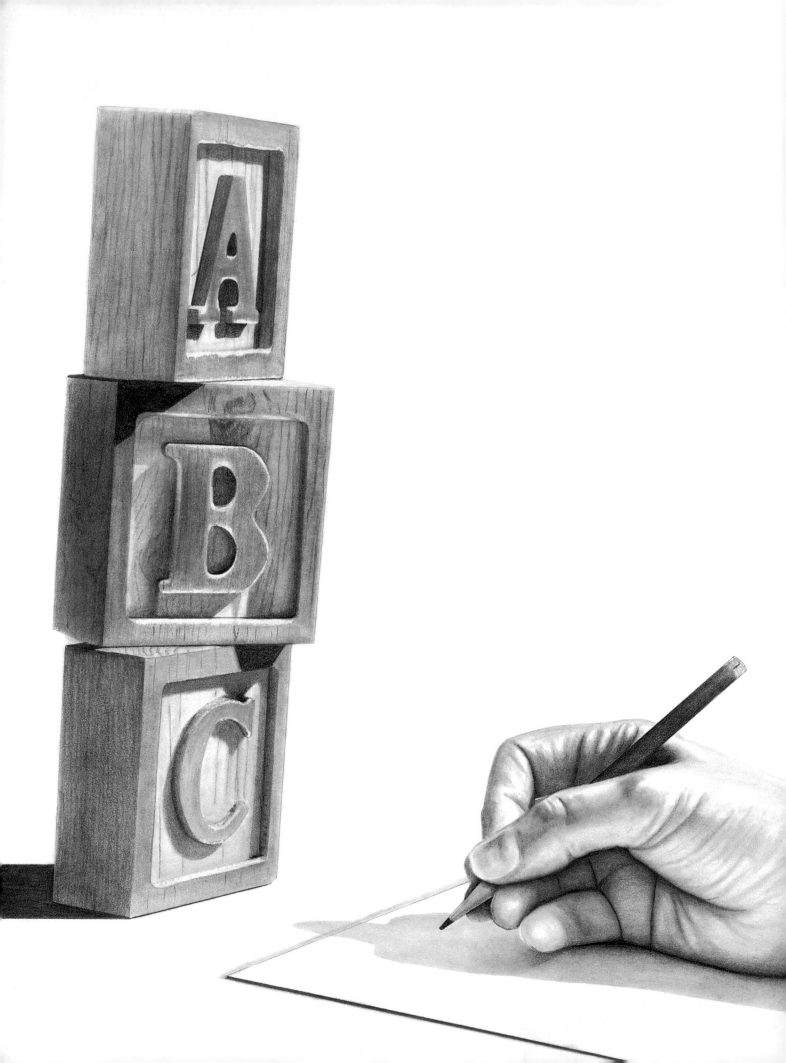

The Right Stuff

Y ou want to know the first secret to drawing? Find the best tools available! You have to have the right toys. Having the proper pencils, paper, erasers and other tools can make a big difference in your art. I'll show you what I prefer, but I fully expect you to develop an addiction to trying out new drawing supplies on your own. Think of it as the chocolate in your art life.

In addition to the right supplies, you need something to draw from. Whether it's a photograph, still life setup, live model or a trip to the great outdoors for some plein air sketching (and maybe a little bug-slapping), the inspiration for your artwork can come in many different forms.

A Group Effort
This drawing was created using a 6B pencil and paper stumps as well as several erasers, including a kneaded rubber eraser and a white plastic eraser.

BUILDING BLOCKS
Graphite on bristol board
16" x 20" (41cm x 51cm)

Something to Draw With

Finding the right pencils to use for your drawings is the first step toward developing your artistic identity. The pencil is, after all, the primary tool of our trade. We can't work without it!

Though the selection of pencils available in most art stores may overwhelm you at first, you'll get the hang of it in no time. Each pencil is clearly marked and labeled according to the brand and type of graphite, making your shopping adventure that much easier. You'll soon enjoy seeking out the perfect drawing implement. Look at it this way: The art store is like a candy shop without the guilt or the calories, and you can have as many pencils as you want!

As with all tools, it's important to experiment with a wide variety to find those pencils that best suit your individual tastes. Here are some of your options.

No. 2 Pencil

This is the standard yellow pencil you always forgot to bring to class when you were a kid. The grade of lead, actually graphite, is called "HB." Don't ask me why—maybe those were the initials of the inventor's mom. It's a nice, middle-of-the-road pencil to draw with.

Hard ("H") Pencils

Pencils labeled "H" have hard graphite. (You could say the "H" stands for "hard.") A hard lead doesn't like to draw. The harder the lead, the lighter the line. The higher the number preceding the "H," the harder the graphite. A 2H pencil is harder than an HB (our old yellow buddy), but not as hard as a 4H. By the time you reach 6H, you have a very vengeful pencil indeed—it can actually indent the paper if you push too hard. Despite your best efforts to erase, its marks will remain scored on your paper.

You might consider avoiding these harder pencils altogether, but they can be useful when working with certain types of paper. For instance, harder leads take well to Clearprint or other drafting papers. You might use 2H pencils to do some of the lightest shading on your drawing before moving on to an HB and the darker leads. They can be used for any subject but require a very gentle hand.

Soft ("B") Pencils

"B" pencils contain softer graphite that results in a darker line. ("B" could stand for "bold.") The higher the number, the darker the line. A 2B pencil is darker than an HB, but not as dark as a 6B. Soft pencils are nicer to your paper, but they, too, have a nasty side: They don't want to leave. If you dive into a major 6B scribble and then decide to erase it, there will always be a faint reminder of your original scribble on your drawing.

Pssssst!

For the illustrations in this book, we will use regular standard leads ranging from a 2H to 6B. No matter the pencil, it is crucial to keep it sharp. A pencil's sharpness is directly related to the success of your drawing. Just remember a dull point equals a dull drawing.

Standard Yellow No. 2
The same pencil that was perfect for filling in all those circles on multiple-choice exams you took in school is fine for drawing.

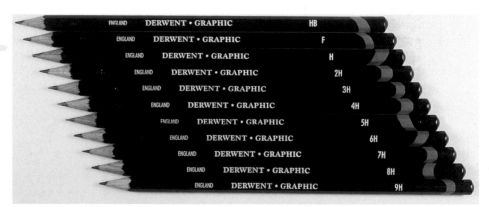

What the Letters and Numbers Mean
Hard pencils are labeled "H" and result in a lighter line. Soft pencils are labeled "B" and create a darker line. The higher the number, the lighter (for "H") or darker (for "B") the line. An HB pencil (like the yellow no. 2) falls in the middle.

Lead Holders

There are a variety of substitutes for the wooden drawing pencil that you can try, including one of my favorites, the lead holder. Rick and I prefer to use lead holders because they sharpen better than regular drawing pencils and can hold various leads. They do, however, require a special sharpener, which in turn requires a bit of practice.

Mechanical Pencils

Mechanical pencils are often mistaken for lead holders. Both implements hold lead in a metal casing that can be reloaded when empty. The difference is in the size of the lead. The lead holder uses 2mm leads; the mechanical pencil holds .3mm to .9mm leads. The latter translates to itty-bitty leads, which break easily and can't be sharpened well. Stick to the lead holder.

Other Possibilities

I have also tried Ebony pencils, which are very dark. Many artists love them, and certainly they're fun to experiment with. I also bought a box of woodless pencils—pure graphite bound in lacquer. They work fine but waste a lot of graphite when they need to be sharpened.

Pencil Sharpeners

You can keep your pencils sharp by using standard sharpeners or special sharpeners that accommodate certain types of pencils (as is the case with lead holders). Some artists use razor blades or other sharp instruments to whittle the wood back off the lead point, and then sharpen the exposed graphite with a sanding block. I personally avoid sharp objects, as I tend to get hurt, but if you're proficient with such tools, whittle away!

Psssssst!

An important point about pencils, if you'll pardon my pun, is to avoid dropping them. If you drop a pencil on a hard floor, the lead inside can break. When this happens, the pencil point will keep breaking off as you try to sharpen the pencil.

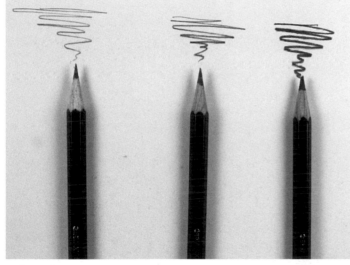

Soft Leads
These are all "B" pencils with soft lead (actually graphite), but their marks vary quite a bit depending on the number.

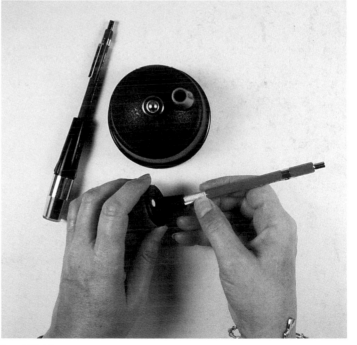

Lead Holders
Lead holders have the advantage of being able to hold various leads. They also sharpen better than regular pencils but require a special sharpener that takes a bit of practice to use correctly.

Something to Erase With (or, Your New Best Friends)

Diamonds may be a girl's best friend and a dog may be man's, but an eraser will be yours. Not only can it eliminate your mistakes, but it also comes in handy for executing shading techniques and creating amazing textures. (You'll learn how to do this a little later.)

Unlike pencils, erasers are not lined up and cunningly labeled for the shopper's convenience, so you'll need to investigate your options before making a purchase. There is a wide selection of erasers available, each varying in hardness (or firmness) and messiness (how much eraser residue is left behind). The upside, though, is that with so many options you're guaranteed to find an eraser that suits your needs.

Pink Rubber Eraser

If you're looking for something that really gets the lead out, it's hard to beat the classic pink rubber eraser. Its firmness makes it an industrial-strength option, able to remove all traces of graphite. Think of it as the eraser wearing black leather and riding a Harley—it's one tough eraser! Be warned, though: pink erasers are rather abrasive and can roughen up the surface of your paper, so exercise caution when using on delicate surfaces.

Kneaded Rubber Eraser

This eraser is a must for every artist. It starts out as a neat little square and soon resembles something you might have to scrape off your shoe. This eraser is best at removing a layer of graphite (as opposed to erasing down to the white paper) and gently cleaning up certain areas of your drawing. You can mold or knead the eraser as needed to reach tight spots without disturbing other nearby areas. You can clean the accumulated graphite off the eraser by folding it back on itself.

For years, the kneaded eraser only came in standard gray, but now colors are available. Faber-Castell offers a superior kneaded eraser in red, blue or yellow that is softer and more pliable than the traditional gray erasers. Check around and you may find other similar options.

Pink Rubber Eraser

Kneaded Rubber Eraser

White Plastic Eraser

I love the white plastic eraser. It can remove pencil marks cleanly and completely. Better still, it leaves behind no residue, and its nonabrasive quality makes it safe for all surface types. It's also quite easy to cut if need be. If the edges of the eraser have worn dull, you can use a knife to make a fresh, sharp edge that's perfect for erasing thin lines.

Portable Electric Eraser

Nothing, I mean nothing, is more fun, more useful or more cool than a portable electric eraser. This battery-powered mechanism has a white plastic eraser tip and works fantastically for erasing in tight spaces or correcting small details. The only setback: It sounds like a dentist's drill!

Gummed Eraser

Probably the messiest of all erasers, the gummed eraser is gentle enough to remove unwanted smudges or marks without damaging your paper, but it leaves behind a dandruff-like residue in the process. Even the cleanest gummed eraser will still make a small mess, so find a brush for whisking your paper clean.

White Plastic Eraser

Portable Electric Eraser

Gummed Eraser With an Artist's Horsehair Dusting Brush

Pssssssst!

Some artists "fix" the graphite on their finished drawings with spray fixative. Personally, I don't usually use such a product because, well, I'll come right out and say it: It stinks. Even if you spray outside, the smell lingers on the paper and will subsequently stink up the house. There are some "odor-free" spray fixatives that smell less awful. Some artists use hairspray, although I'm not sure how safe it is for your art over time. You could simply handle your artwork with care, store it between tissue paper and frame it behind glass at your earliest convenience.

A Few Additional Fun (and Very Useful) Tools

There are several other items you'll want to purchase for your budding art career. I find the following tools to be indispensable when drawing, and I know you will, too!

A Ruler, Circle Templates and French Curves

If you choose to draw anything architectural or mechanical, such as a building or a B-52 bomber, you can either opt to keep it sketchy or aim for a truly realistic look. For the latter, you will need a few special tools: rulers, French curves and circle templates.

None of us can draw a perfectly straight line, so a ruler is a must. Even if you're not drawing a complex subject, you'll want a ruler for such tasks as checking proportions and angles. I prefer a plastic C-Thru ruler, as it has a very useful grid on it and a centering row of numbers. You can find a similar ruler at the fabric store.

Circle templates and French curves are useful for the more uniform parts of the drawings you might do. They are usually made of plastic. Circle templates contain multiple circles of varying sizes, and they are useful for drawing precise circles or arcs. French curves are templates that help you draw other complex curves and shapes. Both of these tools will be discussed at length later in the book.

Erasing Shields and Blending Tools

Made of thin metal, erasing shields have openings of various shapes that allow you to carefully erase lines, highlights or other details without disturbing nearby areas. They are usually available in the drafting section of office supply stores.

Paper stumps and tortillions are used to smoothly blend pencil strokes. A paper stump is a compressed wad of paper, pointed on both ends, that can be used on its side or tip to smooth and shade pencil marks. The tortillion is rolled paper with one pointed tip for use in tiny areas that need smudging.

Psssssst!

If you don't have a fancy art box, a fishing tackle box is perfect for toting around your newly acquired drawing supplies. It has plenty of compartments for storing your goodies.

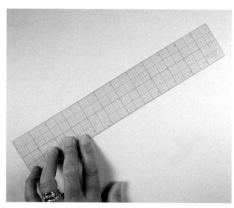

Ruler

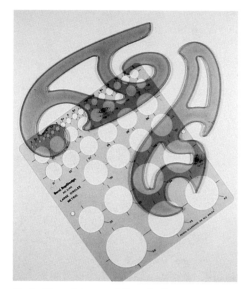

Circle Templates and French Curves

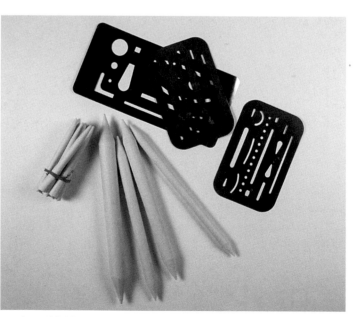

Erasing Shields, Stumps and Tortillions

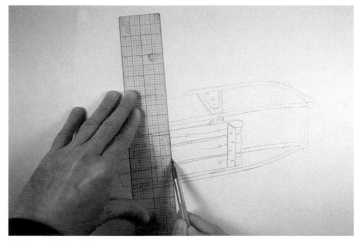

Getting It Straight

There's no law in art that says a manmade object with straight edges has to look mechanically drawn. Freehand lines are very nice, charming in fact, and can look realistic. If you desire to have the object look even more realistic, though, then you should use some type of straightedge such as a ruler.

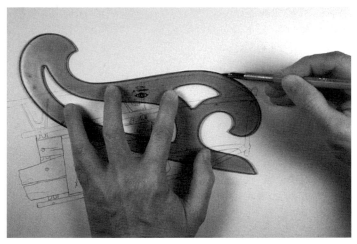

Navigating Curves

A variety of French curves can be of great help when drawing mechanical or uniform curving shapes such as those found on musical instruments, cars, jars with curved sides and arches on doorways.

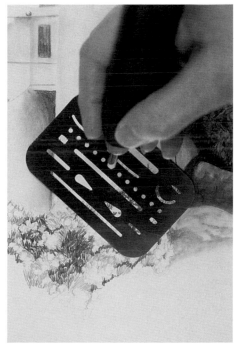

Intricate Erasing

An erasing shield is a handy little device that is quite inexpensive, yet priceless. You can use it to erase various shapes, clean up edges and make even the slightest adjustments.

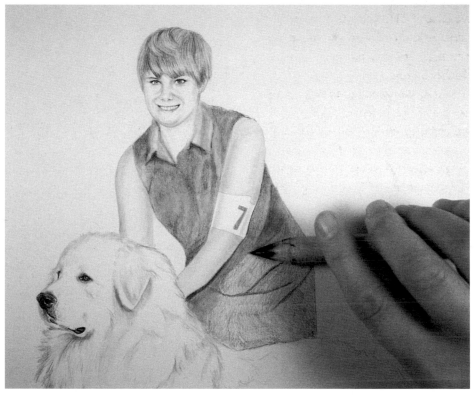

Smooth Blending and Shading

The paper stump (shown here) may be used on its tip or side, unlike the tortillion which is designed to be used on its tip only. If you have a large area to blend, use the stump; save the tortillion for smaller areas. These tools can do more than just blend previously pencilled marks; they can pick up and retain graphite to be used for making their own marks.

A Surface to Draw On

You can draw on almost any surface. Certainly, there isn't a right or wrong paper, only a preference for a certain look or feel for your drawing.

One of the first things to consider when choosing paper is thickness. I like to do my finished drawings on bristol board. It's very heavy and forgiving, allowing me to correct many mistakes without jeopardizing the surface. Thinner surfaces like newsprint are more sensitive to erasers and harder to blend on; they just don't work that well. The only real benefit in buying thinner paper is that it saves you some cash.

Another consideration is surface texture. The texture, or tooth, of your drawing paper is determined by touch and makes quite a difference in the final appearance of your work of art. The paper designated as smooth or plate finish allows for a finished drawing with lots of detail. The individual pencil strokes tend to blend together well because the graphite will fill in evenly on the paper surface. The bristol board I use has a smooth finish.

Papers labeled medium, regular or rough have more texture, causing the surface to grab the graphite in an uneven manner. The rougher paper holds more graphite, allowing for deeper shadows and more contrast, but results in a grainier drawing.

In addition to buying paper for your finished drawings, you'll also want to stock up on tracing paper. Tracing paper is useful for a number of tasks, such as keeping your drawing paper clean and spotting (and correcting) errors in your drawing. Later we will cover the use of tracing paper in more detail.

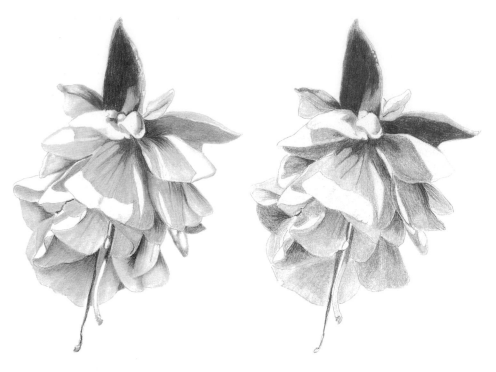

Smooth Sailing
This fuchsia was drawn on smooth bristol board. Smooth paper gives your drawing a softer, less sketchy look. It works well for smooth skin tones, glass and other slick surfaces. Of course, you could intentionally use rougher paper for smooth subjects to create interest.

EVELYN'S FUCHSIA
Graphite on bristol board
10" x 8" (25cm x 20cm)

In the Rough
This one was drawn on regular drawing paper, which has more tooth. Rougher paper adds texture to your drawing, which makes it a good choice for highly textured subjects like landscapes, animals, stone and so on. Between these two drawings, I liked the smoother surface better, as the drawing looks more delicate.

EVELYN'S FUCHSIA II
Graphite on regular drawing paper
10" x 8" (25cm x 20cm)

Pssssst!

If you buy paper in a spiral-bound pad, place a piece of cardboard underneath the page you're working on so you don't score the page underneath. After you finish the drawing, put tracing paper over it to protect from unwanted smudging.

And while we're on the topic of pads: Either buy sealed ones, or if none are sealed, take from the bottom or back of the stack. Pads that are unsealed or in the front may have been fondled by other shoppers, and the oils from their fingers ruin the paper.

A Place to Work

Now you need a place to lay your supplies and go about the business of drawing. A full-size drawing table provides a firm, steady surface and enough room to rest your arm as you draw. The table angles so that your drawing paper is parallel to your eyes, which minimizes the chance for visual distortion as you work.

Your pencils, erasers, sharpeners and other tools should be arranged in an uncluttered fashion and made easily accessible for drawing. It helps put you quickly in the mood to draw if you can leave your art materials set up in a designated area. I have a studio where I keep my table, along with a taboret (or art-supply caddy), pencil tray and a light.

Rick, of course, has two drawing tables, and they're bigger than mine. It's one of those things I have learned to live with.

If you have limited space or want to carry your studio with you, consider a portable drawing table. I have a dandy one that has a handle for easy transport and whose angle is somewhat adjustable (though not as much as a larger drawing table). Homemade drawing surfaces work just as well, as long as they are firm and steady. Use a clipboard or a piece of smooth material such as Masonite or plywood with the addition of bulldog clips or drafting tape to hold your work in place.

Pssssssst!

To protect your art supplies from damage or loss, put them away after each use. Otherwise, husbands, wives or kids may grab your favorite 2B pencil the next time they take a phone message and promptly lose it. Or worse, your cat or dog might find your kneaded eraser an interesting toy or munchie, ruining the eraser and possibly getting a tummy ache. Be kind to your supplies, and to your pets!

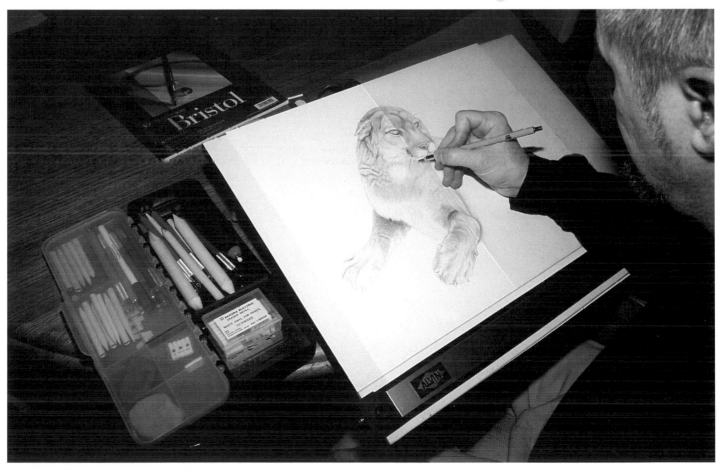

Back to the Drawing Board
This portable model can make any place your art studio.

Drawing From Photographs

Once you've rounded up all the essential supplies, where do you find inspiration for your drawing? Chances are that long before you picked up your pencil, you knew what you wanted to draw. Maybe you wanted to draw the adorable action of one of your kids or grandkids, the way the sunlight lit up a particular rose in your garden or the swans you saw on the lake during your last vacation. The desire to capture something meaningful and personal to you for all time in a unique expression is the motivation that drives most artists.

You'll make your life a lot easier and your drawings a lot better if you start with a good photograph. For one, photos freeze an exact moment in time, alleviating the pressure to memorize a scene or face. Add to this the fact that you don't have to deal with squirming subjects or changing lighting conditions, and the argument for using reference photos is pretty solid.

Not just any photo will work, though. Here are a few important considerations for shooting and choosing good photos.

Size Matters

As obvious as it sounds, you need to be able to see the information in a photo in order to draw it. Use a photocopier or scanner to enlarge smaller images so the details are able to be seen. And when you do enlarge the photo, make sure the details are still clear enough to draw from. The more you enlarge a photo, the grainier the quality will become.

Stay Focused

Only work with photos that are in focus. The reasons behind avoiding blurry photos are pretty obvious. You can't see the details, so you might have to make them up. All in all, a bad idea.

Candid Camera

Most of us have quite a few shots of our vacations, family gatherings and favorite critters. You have a new assignment: shooting photos with future drawings in mind. Don't just take a photo of Aunt Millie in front of a waterfall. Photograph the waterfall itself, the rocks around it, the moss on the surrounding trees, the butterfly that landed on a nearby wildflower … you get the drift. Become a shutterbug if you're not one already. Get close to something, *really* close, then step back and try shooting from another angle.

Pay attention to the effects of light on your subject. Don't just take a picture of your friend—have her put on a nifty hat that filters light in an interesting pattern. Set a basket of vegetables you gathered from your garden near a window that receives early-morning sun. Then try setting it in a different window during the late afternoon to see how the light falls differently on the veggies.

Shoot at least half a roll of film on any given subject, and several rolls when it's a particularly exciting subject. Go to places that lend themselves to getting great

Think Big
Don't expect to turn out a good drawing of your subject if your reference is too small to gauge details. Trying to do a facial portrait from a photo in which the face is a dot is self-defeating. Rick is so far away in this picture that there's no way I could accurately draw his face!

shots, such as a zoo or national park. And by all means, ask others for assistance. We have asked bird breeders to bring their feathered friends over for photo shoots. (The drawing on page 64 came from such an experience.)

Pssssst!

It may be tempting to use a photo from a book or magazine, but these pictures are copyrighted. So are studio portraits taken by other photographers. Bottom line: If you don't own it, you shouldn't draw from it. I know you're saying, "But I just draw for myself. What does it matter?" However, because it's a good, clear photo, you'll inevitably turn out a nice drawing, and you'll want to show someone. They'll say, "Hey, that's great! You should put that drawing in a show!" And before you know it, you'll get a call from so-and-so's lawyer that you have infringed on someone's copyright. Don't take that first fateful step down the path to ruin!

Editing What You See

A photo captures what's there, but artists aren't limited to the photo. Just because a tree is in a certain spot in your picture doesn't mean you need to draw it that way—or even draw it at all. Although we emphasize the use of photos, you're not a human copier machine. You can simplify, rearrange, include, exclude, change and exaggerate the various elements of your reference photos to make the drawing you want. You want your drawing to do more than merely record, as a camera does. You want it to tell a story, to reflect your view of the subject—and ultimately, to captivate the viewer.

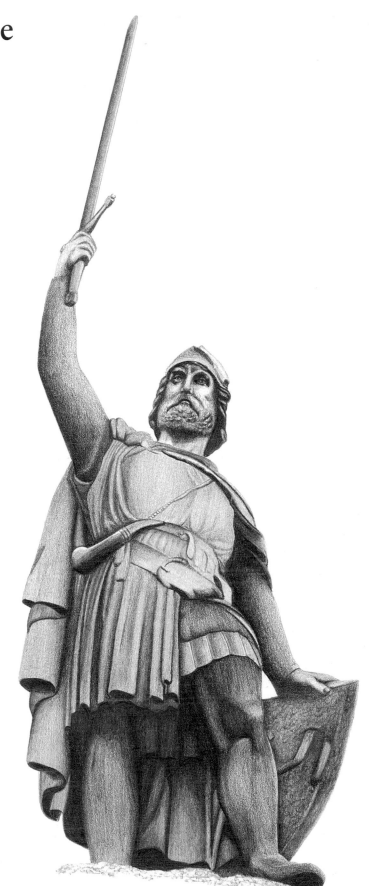

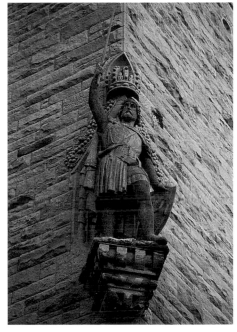

Reference Photo
A few years ago I took a trip to Scotland, where I photographed this statue on the William Wallace monument in Stirling.

Finished Drawing
Rick simplified the legs, removed the stonework surrounding the figure and darkened the shadows, allowing for more drama.

Combining Photo References

Not only do you have the ability to change what you find in a single photograph, you can combine several photos for a single drawing. After all, trying to photograph a litter of puppies, four little children, or both sets of in-laws who live two thousand miles apart is waaaay too much work. You can also create a composite drawing of family members who have passed away, every dog you've ever owned, or other things that could never be grouped together for a photo. Composite drawings can enhance reality or make the impossible possible.

Let's look at how the drawing on the opposite page was created using a number of different photos.

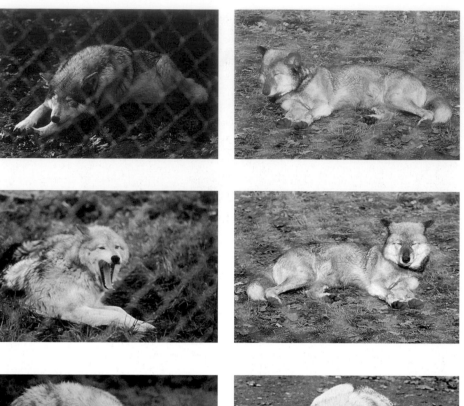

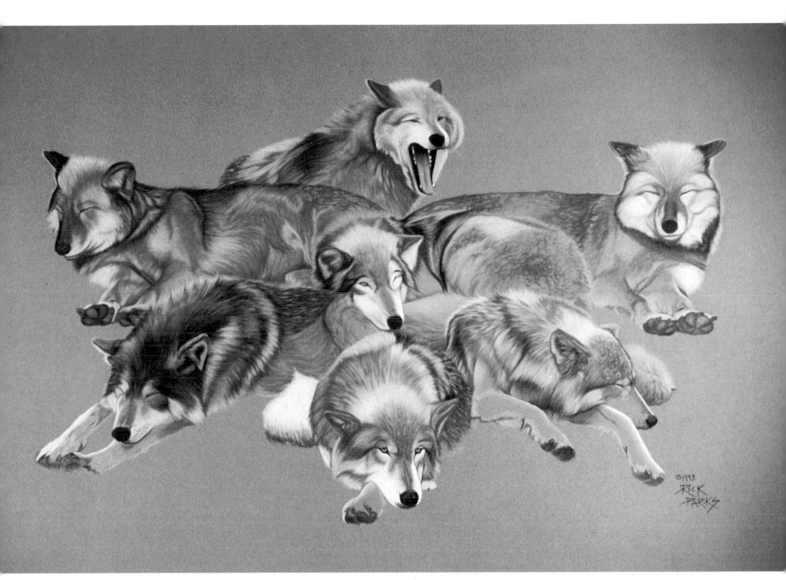

Finished Composite
This composite drawing was derived from seven photos taken at Wolf Haven in Tenino, Washington. The wolves were arranged in an interesting pattern, and the ground was implied, not drawn. Rick named it *Monday Morning* because he thought the body language of these wolves resembled the appearance of his fellow workers around the watercooler after too short of a weekend.

MONDAY MORNING
Pastel pencil on toned paper
24" x 36" (61cm x 91cm)
Collection of Frank and Barbara Peretti

 Psssssst!
There are two tricks to making good composite drawings. The first is getting the proportions of the combined elements correct so that everything looks like it naturally goes together. The second is a consistent light source, especially when the lighting is different in every photo. You may need to do a bit of research or ask questions when combining images.

Drawing From Life

I used to do most of my drawing from life—rendering the subjects in front of me rather than working from a photo. I wasn't attempting to be artsy, I just didn't own a good camera. One way to draw from life is to draw on location, which the French refer to as *plein air* drawing. The idea is to hike somewhere with your drawing equipment, sit on the wet ground, swat at bugs, unwittingly find poison ivy, get sunburned and draw a so-so sketch which gets soaked in a sudden monsoon on the way back to your car. Sounds fun, huh?

Why Bother?

You might think I'm not too fond of plein air sketching. That's not entirely true; drawing on location does have its benefits, and I've been known to take advantage of them occasionally. Plein air sketching, along with general drawing from life (which doesn't necessarily have to occur outdoors), allows you to register the mood of a location and the immediacy of the scene. However, it also forces you to deal with unwanted movement and ever-changing lighting conditions.

For these reasons, it can be a lot harder than drawing from a photo.

One time I sketched a black Labrador retriever for a lady. He was a very nice dog, holding still for long periods of time and moving only very slowly. Unfortunately, *because* he moved so slowly, I didn't catch the fact that his head was slightly turned to the left when I started drawing the top of his head, facing me straight on when I drew his eyes, and slightly turned to the right by the time I finished his nose. Not my best work, believe me!

The best of both worlds is to tote your camera, sketchbook and notebook on location when you draw. Photograph the scene or subject from several angles, then sketch and make notes about your feelings, the colors (if you plan on eventually turning this into a painting) and your ideas for incorporating what you see into a finished work. Think of the possibilities! You can take that great old photo of Grandpa McCandless and place him in front of the antique car on display at a car show. Keep a collection of your sketches, photos and notes, which will

Psssssst!

Always carry a camera with you when heading outside to draw. That way if the experience is not all it's cracked up to be, you can at least get some good reference photos out of it.

come in especially handy on those rainy days when you'd rather make a drawing than watch another rerun on television.

Drawing on location can be both exciting and beneficial to the artist, but it's not as easy as working from photo references. It's more challenging because the wind tosses the leaves, critters wander off and people don't hold still. Drawing from photos in the comfort of your studio or workspace means you can take your time, a luxury you usually don't have when you draw from life. Give drawing from life a try, but don't beat yourself up if you find it to be difficult.

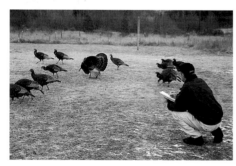

Hold Still!
Rick and I have a herd of turkeys that has taken a shine to our land, so naturally we photograph, sketch and paint them. Turkeys, being, well, turkeys, do not hold still. This is one of the many challenges of drawing from life.

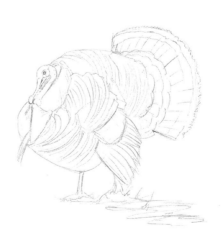

A Plein Air Sketch
Rick couldn't capture all the feathers or the shading, but he did try to get the feeling of movement and the roundness of the turkey.

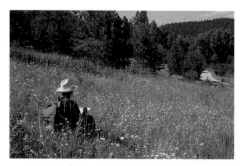

Taking It All In
It can be exhilarating to take in a scene firsthand, as it provides you with an opportunity to use all of your senses. Choose a comfortable spot with a good view. And be sure to check the weather forecast before heading out!

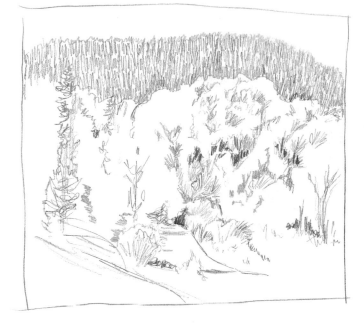

A Plein Air Sketch
This is a sketch of our upper field and the dirt road that leads to our house. The hillside was covered in flowers, which in turn were covered with bees. Rick quickly sketched the scene, seeking the various shapes, shades and textures of the vegetation on a summer day.

Finished Drawing
Plein air drawings capture a freshness, spontaneity, action and movement that is unique to the art. This finished drawing was created mostly from the rough sketch with a few more details added from a photo taken the same day. It is deliberately loose in execution.

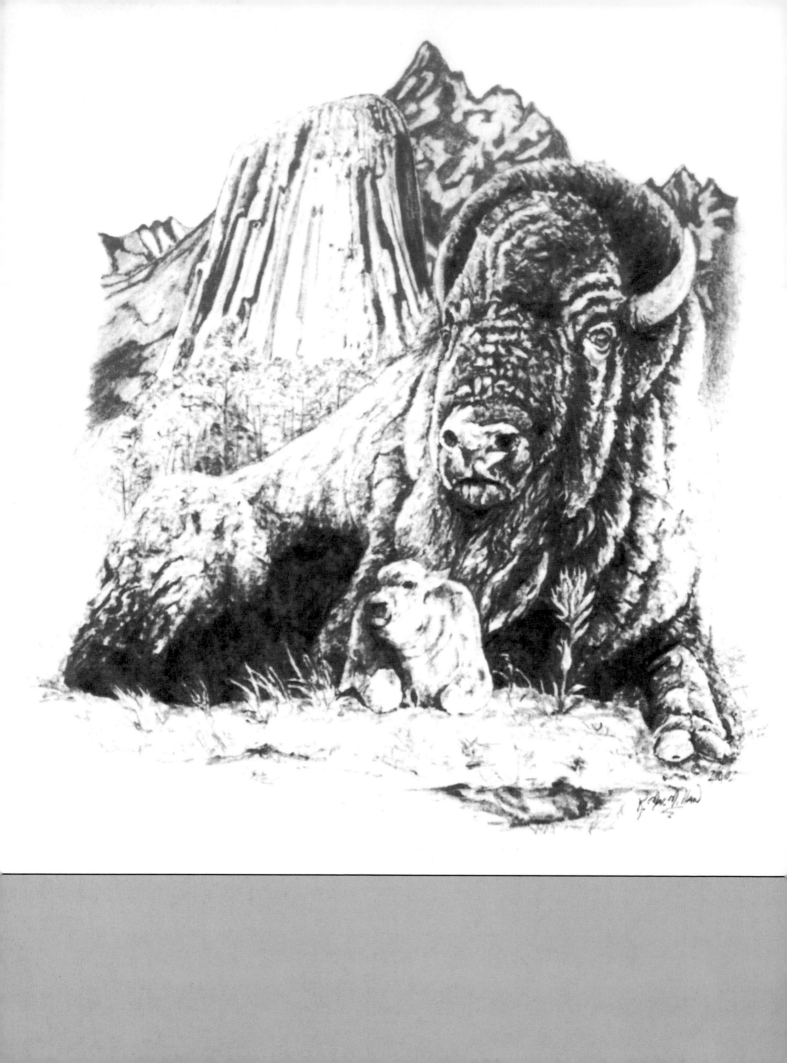

So the Problem Is...

Drawing Is Seeing
Learning to draw involves learning to see. To draw this buffalo, Ken worked from reference photos taken in his native state of Wyoming. Although he already had a keen eye for drawing animals, Ken attended our course on composites to hone his face-drawing skills.

WYOMING PRIDE
Ken MacMillan
Graphite on bristol board
9" x 12" (23cm x 30cm)

Why haven't you been able to draw up to this point? The usual response is that you're not an artist or that you lack the talent. Actually, if you can't draw it's probably because you never truly learned how. Drawing is like reading, a skill learnable by almost everyone. Some people end up loving to read, maybe even writing books, while others can barely get through an e-mail. In each case, the fundamental ability to read is there. The only difference is how much you enjoy (and therefore practice) the task.

To understand why it's difficult for many people to draw well naturally, we are going to look at how our brains work (or don't work, in some cases). I'll share the immediate and practical observations I've had while teaching people how to draw. Once you understand how your mind processes the world around you, you can then train yourself to really see your subject and move on to creating accurate, realistic drawings.

The ABCs of Drawing

Let's continue with the analogy of reading to address some of the fundamentals of drawing. You first learned the alphabet as a series of shapes. You committed to memory the shapes of twenty-six letters (actually, fifty-two when you count both lowercase and uppercase). You memorized the letters and the sounds they made. You might even have learned by placing the alphabet into a song: "A-B-C-D …" and so on (although the letter "ellameno" took some time to figure out!). Then you combined the letters to form simple words like cat, dog, run and see.

In drawing, there are really only two kinds of shapes to learn: straight and curved. These simple shapes can be combined to form simple, recognizable images. All of us are able to combine straight and curved lines to create the simplest of drawings.

In reading, you eventually progressed to more and bigger words. With each passing day, you acquired more and more words for your memorized dictionary. Then you strung the words together to form sentences. In art, you might have taken a turn at drawing a more complex critter or car.

Here's where the natural artists and the rest of the world part. The natural artists develop a few skills to move on and draw more accurately. Everybody else figures there's no hope and throws down their pencils in disgust.

So what's the problem then? Why can't your drawings progress past this most basic stage? Understanding how your mind works can help you overcome this roadblock.

A B C D E F G H I J K L M N
O P Q R S T U V W X Y Z

Mastering the Shapes
Learning how to read demanded that you memorize the shapes that made up each letter. Learning the letter R, for example, required you to learn the series of curved and straight shapes that combined to form the letter.

Duplicating the Shapes
After a bit of practice, you were able to recognize all letters of the alphabet and the series of curved and straight shapes needed to duplicate or write each letter.

cat ran the see look

Combining the Shapes
Once you memorized the entire alphabet, you could then combine letters to make words. Likewise in art, you can combine basic straight and curved shapes to form simple drawings like this cat. You've gotten this far in your drawing skills already. The goal is to move forward.

Thinking in Patterns

The human brain is very efficient. It processes information at an astounding rate, then places that information into a memorized pattern so it makes sense to us in the future. For instance, we learn to recognize letters of the alphabet by memorizing their shapes. Once memorized, these shapes are stored in the brain and recalled when necessary. It is this ability to recall information that prevents you from having to relearn the alphabet every time you sit down to read.

The same process applies to objects around us. Your brain records a recognizable pattern for each object and recalls that pattern when necessary. So why doesn't the object in your drawing look like it does in real life? The answer is simple: When you draw, it is the memorized pattern that you usually reproduce on paper, not the reality of the object in front of you. Anything unique about the object you see may be lost when your brain recalls the pattern on file.

Along with stubbornly adhering to memorized patterns, your brain records only essential visual information, not every single detail. To prove this point, try drawing a one dollar bill without looking at it, and then compare it to the real thing. Notice any differences? Even though you've seen the dollar bill countless times, your brain hasn't recorded the exact details. In fact, you've likely only stored enough information to distinguish this piece of currency from any other piece of paper.

This means our mental patterns of most objects we want to draw are missing the details necessary to make the object appear realistic. You may be wondering, then, how veteran artists are able to crank out realistic drawings without even breaking a sweat. This is because our brains continually add shapes and images to our dictionary of patterns. For example, you have learned to read a sentence regardless of the font or handwriting style used. The same happens with drawing: Artists who have been drawing for some time have a large dictionary of patterns that they have been adding to over time. They have probably sketched them many times as well.

So how do you build your dictionary of patterns and ultimately improve your drawings? It's all about understanding perception, which we'll talk about next.

The Problem of Primitive Patterns
When we write, we rely on our memorized shapes to communicate. That's fine for writing but lousy for drawing. Memorized patterns seldom help us create realistic drawings when we're starting out. This is the case with each of the objects pictured here. Sure you can recognize the objects, but they are a far cry from realistic representations. You must expand your mental dictionary of patterns if you want your drawings to improve.

Understanding Perception

One of my favorite poems explains the role perception plays in our lives. In "The Everlasting Gospel," William Blake writes:

This life's five windows of the soul,
Distorts the heavens from pole to pole,
And leads you to believe a lie,
When you see with, not thro', the eye.

The five windows Blake refers to are the five senses, the means through which we understand and record the world around us. We call this *perception*, and like Blake suggests, sometimes our perceptions can lead us astray. However, if you have a proper understanding of perception and how it affects your view of the world, and thus your art, you'll be better equipped to develop strong, solid drawing skills.

A good definition of perception is the process by which people gather, process, organize and understand the world through the five senses. Keeping this definition in mind, there are two important points that every artist should know about perception.

First, each of us has a filter that affects our perceptions. By shaping your filter to meet your interests, you can build upon your dictionary of patterns and develop your artistic skills. However, it can be a challenge to alter your perception without study and practice.

This brings us to the second point—perceptions are powerful. So powerful that they don't change unless a significant event occurs. In drawing, this significant event is training.

Shaping Your Filter

Perception filters exist solely to keep us from overloading on too much information. If we didn't have filters in place, we would suffer from sensory overload. As handy as your filter may be in everyday life, it needs to be shaped or altered for you to become a proficient artist.

Pssssst!

When you first begin to draw, your mental dictionary of patterns is limited and untrained, and your perception filter is in full effect. Test your knowledge of the objects around you by drawing them without looking. This exercise results in repetition of known shapes. If you have learned that object accurately, you will be able to reproduce it accurately. If you practice this often enough, eventually your filter will change to allow more details in.

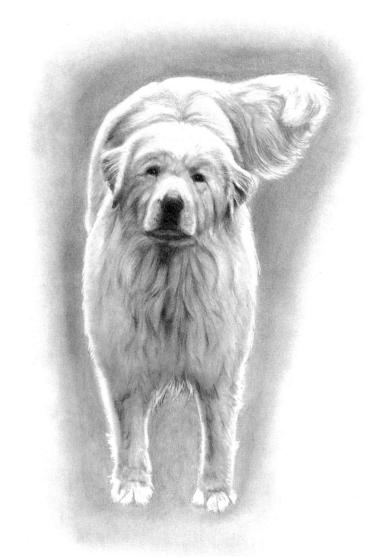

Training the Eye
As an artist, you must be able to hone your perception of a subject and articulate what you see. Your average dog lover might look at this Great Pyrenees and see a pretty white dog, but a dog show judge or breeder will be able to rattle off the characteristic details that make it "pretty." You want to be able to see with the eyes of a judge or breeder.

Imagine for a moment that you're at a dog show and a beautifully groomed Great Pyrenees trots by. If you are an average guy who has a soft spot for animals but who doesn't possess extensive knowledge of dogs, you might think, "what a pretty white dog." However, if you are a judge or Great Pyrenees breeder, you might think, "good oblique eye, excellent shoulder layback and level topline." The judge or breeder has honed his ability to look past the filters and really see all the details of the object he is dealing with—or at least enough detail to know a good Pyrenees when he sees one.

Just as the Pyrenees expert developed accurate perceptions by shaping his filter, you too must alter your filter to really *see* your object of interest. Becoming a successful artist means training your eye to recognize key information and retaining it in your dictionary of patterns. If you don't alter your filter, your perception will continue to be shaped by the limited original patterns stored in your brain. Your drawings will never improve until you learn to see all the details that make up your subject.

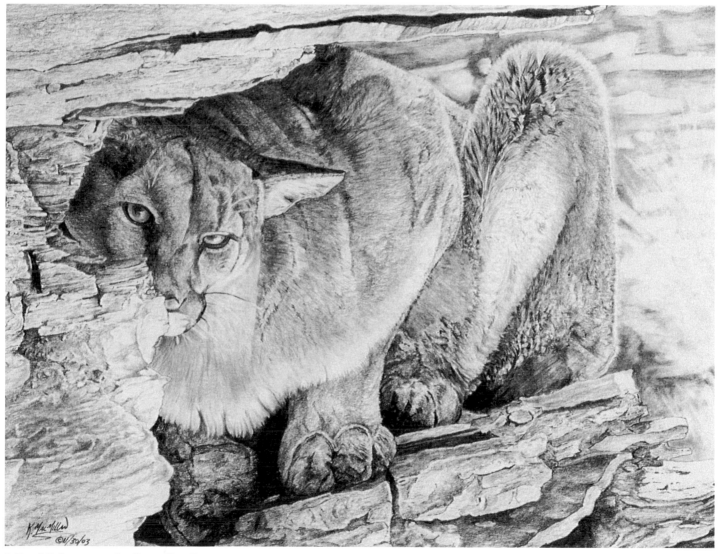

A Good Reference and a Perceptive Eye
A clear reference photo and the ability to perceive its many details allowed this artist to capture the reality of the cat.

I CAN SEE YOU
Ken MacMillan
Graphite on bristol board
9" x 12" (23cm x 31cm)

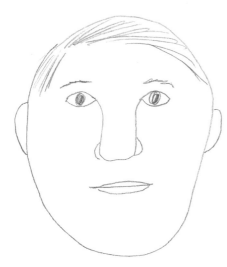

Drawing With an Untrained Eye

The average person with no art training will draw a portrait like this one. Even looking at a reference photo won't help; they'll still make the same mistakes. For example, the artist of this portrait placed the eyes in the top one-third of the face. In reality, the eyes are typically located about halfway down the face. This fact is clearly provable by looking in any mirror, yet it was missed here. Your perception, fueled by the original patterns stored in your mental dictionary, is so powerful that even the most easily checked data is invisible to you.

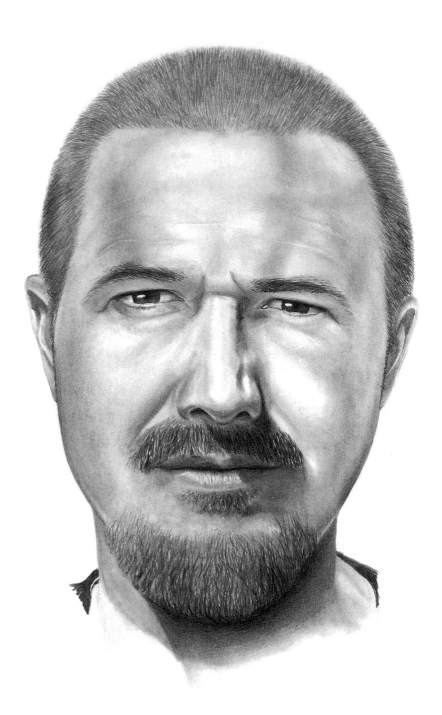

Getting It Right

Although I have drawn faces for years, I have to study the face I'm drawing just as diligently every time as I did for my first drawings. I have to make an effort to really take in each individual face that I draw. Easy? Not at all. To make your drawing of a person resemble your source, you should be aware of standard rules of thumb (or patterns) for drawing faces, but you can't rely entirely on them. Almost every drawing book on faces contains at least one drawing mistake, generally in the size of the iris or the length and width of the nose. In my forensic art career, I've had the chance to really study, record and measure faces because I've had access to thousands of mug shots in my composite drawing classes. I've projected them and measured those thousands of faces, recording the subtle information in the reality of the photos, not the opinions of other drawing books.

You Can Improve—Here's Proof!

So you're aware that your filter must be altered to change your perceptions and improve your drawings, but how do you go about doing this? After all, our perceptions are so steadfast that they usually don't change unless a significant event occurs. Exactly what will it take to get this stubborn ball rolling into motion, then? You guessed it—training. Without training, you will probably be discouraged by your own efforts to learn. Any progress you had hoped to make will be stunted by the frustration of not being able to draw what you see. Don't worry, help is here! With this book and some practice, you'll be able to draw anything realistically.

There are four main components to making a good realistic drawing of anything: site, shape, shading and accuracy.

You need to know what the parts look like (shape), where they go (site), what the finished product looks like (how to make it real—shading) and how to fix the wobbly parts (accuracy).

After practicing basic pencilling techniques, we'll work on the four components. By developing each of these skills you will change your perceptions and improve your drawings at a vastly increased rate. I will share every secret I know and hold back no technique that will help you achieve your dreams of becoming a better artist.

I promise it's possible! Don't believe me? Check out the before-and-after drawings on the following pages, done by two students from my composite drawing courses.

Pssssst!
Don't trash your old drawings! Save them as you go. Embarrassing as they may be, they will help you chart your progress and someday show just how far you've come.

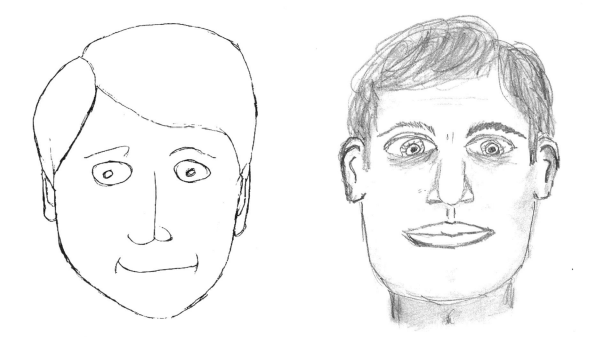

Before Instruction

In our composite drawing classes as well as our portrait classes, Rick and I begin by explaining about pencils, erasers and paper. We then ask the students to draw a face. These two examples by John Hinds (left) and Greg Bean (right) are average pre-instructional sketches. John was then a detective with the Snohomish County Sheriff's Department in Everett, Washington. His goal was to draw and he was determined, but he had never drawn anything more advanced than a smiley face. Greg, also a detective with the police department in Bellevue, Washington, enrolled in the class convinced that he would never learn to draw, but he felt it would improve his identification skills.

"Merry Beth"

After Instruction

John immediately put his newfound drawing skills to work. One of his earlier composites identified the largest serial arsonist in United States history. John retired from the department and was drawing portraits and teaching art within a few years of his first one-week drawing class.

John's more recent drawing of his wife, Merry Beth, shows how he has learned to let lights and darks create the image. He's moved away from outlines and developed his own style. He's simplified some of the shapes and suggested others, focusing the viewer on Merry's eyes.

MERRY BETH

John Hinds
Graphite on bristol board
10" x 8" (25cm x 20cm)

Pssssst!

Those who draw the best tend to have the best observational abilities. Thankfully, this is something we can work on rather easily.

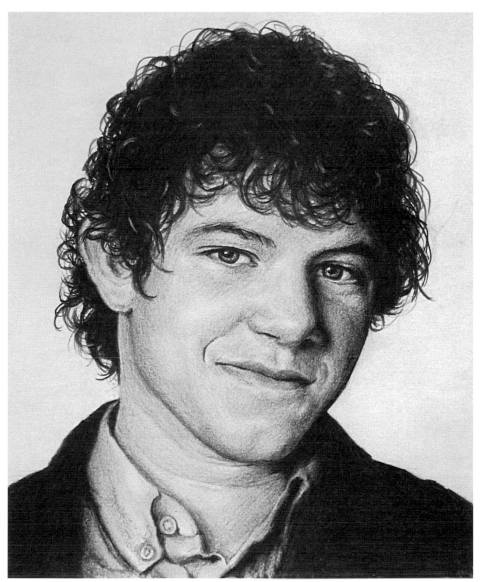

After Instruction
Greg seldom let his pencil out of his hands and within a year was advanced enough to help me with a new class. It's been about five years since Greg took his first class, and the results of his diligent practicing are apparent in his drawings.

JEREMY
Greg Bean
Graphite on 8" × 10" drawing paper

Cheat Sheet

- *Drawing is a very learnable skill, much like reading. Both involve the ability to recognize shapes and then combine them for words or drawings.*

- *Your brain stores limited information about what you see, then recalls these memorized patterns when you try to draw something.*

- *Beginning artists have a very limited dictionary of memorized patterns.*

- *Your drawings will greatly improve if you can learn to see objects as they are in reality instead of reproducing a limited pattern from your memory.*

- *You can expand your mental dictionary of patterns to become a better artist.*

- *Everyone has a perception filter that limits what we process when we look at something. Otherwise our brains would be overwhelmed with information.*

- *You will see and draw your subject better if you shape your filter—that is, train your eye to recognize key information and retain it in your dictionary of patterns.*

- *With solid training (this book!) and frequent practice, anyone can learn to draw well.*

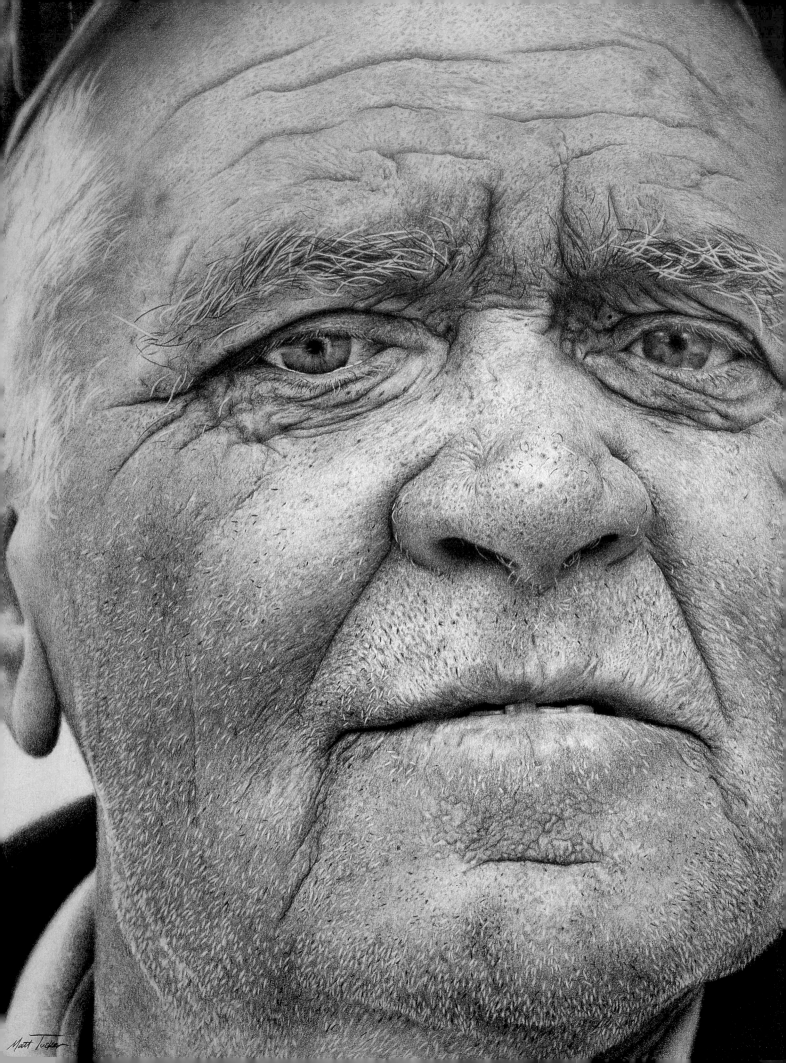

Making Your Mark

Up Close and Personal
The artist used his pencil in tight strokes to create this highly realistic drawing. The man's whiskers were erased (or lifted out) and then defined in pencil, a technique you will learn in this chapter.

THE BUM
Matt Tucker
Graphite on 300-lb. (640gsm) cold-pressed illustration board
21" x 16" (53cm x 41cm)
Collection of the artist

Chances are you've already tried to draw your favorite subject on your own. If you didn't get the results you were hoping for—and you most likely didn't if you bought this book!—your inaccurate (or incomplete) perception of your subject may not be the only culprit. Your technique of putting pencil to paper may take some of the blame. Maybe your rendering was close, but not quite right. That's okay! The first step is to actually get off your duff and give it a try. From there it's all about practice.

Before ballet dancers start dancing, they practice their positions. Singers go through pre-concert vocal warm-ups. A writer might start the day with some journaling or maybe a cup of coffee. As an artist, you're in the same boat—you need to warm up before you cut loose. Consider this chapter your pre-drawing warm-up. It's designed to get you drawing and using your tools correctly. All the tools, techniques, secrets and ideas won't help you without some practice, so grab your box of drawing goodies and let's get going.

Contour Drawing Warm-Up

One excellent warm-up practice is to do a contour drawing. There are two kinds of contour drawings: regular and blind. Both types involve placing your pencil on a piece of paper and not lifting it until the drawing is complete. The idea is that as your eyes are moving across the subject you have chosen, your pencil is moving across the paper in the same manner.

How do these two types of contour drawings differ then? The answer lies in whether or not you look at your hand while in the process of drawing. In a regular contour drawing you have the freedom to look at both the subject and your hand as you work. But a blind contour drawing, as the name suggests, requires that you lock your gaze on the subject entirely, never looking down at your hand as you draw.

Now, contour drawing may sound stupid or like a waste of your time, but the point is to train your eye and hand to move together at the same time and at the same pace. This ultimately forces your eye to slow down and more carefully observe the object so your hand can keep up. Just give contour drawing a shot—it'll be fun, I promise!

Pssssssst!

Contour drawings don't always have to be of a lone object. You can do a contour drawing of an entire scene or landscape. Though your pencil shouldn't leave the surface of your paper when you are drawing just one object, it is okay to quickly lift your pencil when drawing multiple objects if there is dead space between them. Only do this when necessary, though: The space between the objects should be significant enough to justify lifting your pencil.

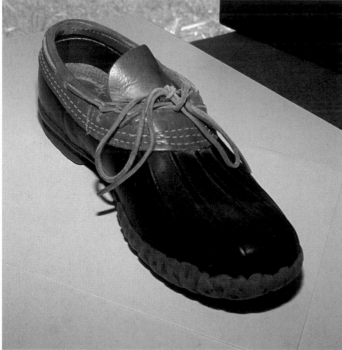

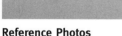

Reference Photos
I used this shoe and copper teakettle to complete the contour drawings on the next page. You can practice contour drawing with just about anything you have laying around the house.

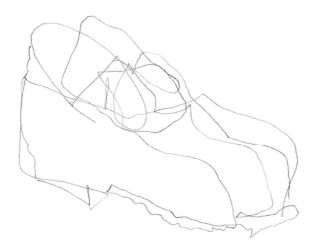

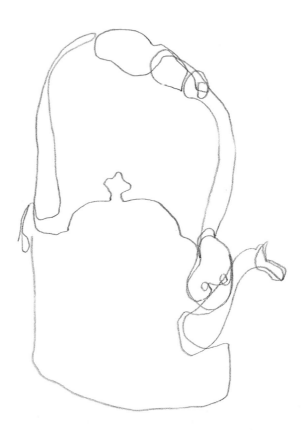

Blind Contour Drawing

Choose a starting point on the object, then place a piece of paper under your drawing hand and put the pencil down on the paper. Turn your body so you can't peek back at your hand. As you start drawing, your eyes and your hand should be in sync. That is, as your eye moves slowly around the object, your hand should record the exact part of the image on which your eyes are focusing at any given time. Let your eye explore each shape and area of the object as your hand does the same. Don't lift your pencil from the paper until the drawing is complete—and no peeking at your paper! When you're finished, you should end up with a scribble that kind of resembles your subject.

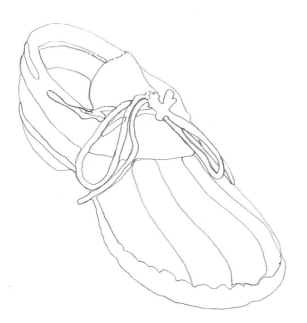

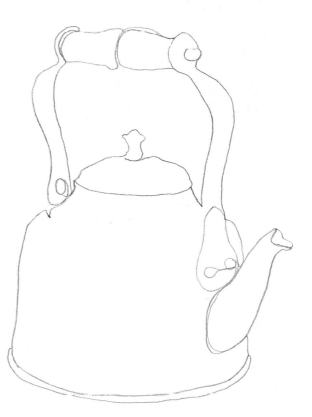

Regular Contour Drawing

Begin this drawing in the same way, only don't bother turning your body so that you can't see your hand. This time, you can freely look back and forth from your paper to the subject, but you still can't lift your pencil from the paper until the drawing is complete. No cheating! Your regular contour drawing will more closely resemble the actual subject.

Pencilling Techniques

Drawing is as simple as placing pencil marks on a piece of paper. The selection of drawing marks available to you is as varied and unique as your own hand-writing. There are no correct or incorrect marks, only more or less effective ones in meeting your drawing goal.

This is not a comprehensive list of marks, only the types we will be using for the illustrations in this book. You can use these marks for creating interesting textures and shading, as well as just plain filling in the spaces of your artwork.

Hatching

Hatching involves drawing parallel lines on your paper. These lines should be varied at the points where they begin and end to prevent unwanted hard edges from occurring. Vary the distance between the lines to create lighter or darker areas.

Generally, your lines should follow the form of your subject, indicating roundness—though drawing all the lines in the same direction can be a style choice done purposely for an interesting drawing.

Crosshatching

Crosshatching starts the same way as hatching does, with parallel lines. Once the first set of lines are drawn, a second set is placed over them at an angle. If more depth is needed, a third and fourth layer may be added. The crosshatching may continue for as many layers necessary to create the desired darkness.

 Pssssst!

The techniques of hatching and crosshatching are often used by pen-and-ink artists to create shadows.

PRACTICE BUILDING UP LAYERS

A more challenging technique, but beautiful when completed, is using multiple pencils with different grades of graphite to create shading. You create the changes in lights and darks by gradually and gently lifting your strokes. Although this technique requires more hand control and is rather labor intensive, the advantage is that corrections such as modifying your darks are easier to make.

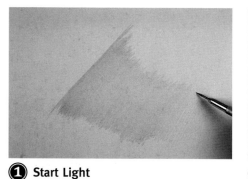

1 Start Light

Using a 2H pencil, smoothly scribble back and forth over a distance of several inches. Halfway across, start to lighten the pressure on your pencil so that the end strokes are quite light.

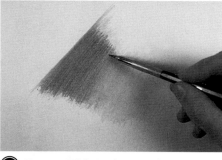

2 Repeat With Darker Lead

Now take an HB pencil and repeat the process going over the 2H scribble, but this time end your strokes at the halfway point of your first scribble, where it began to lighten.

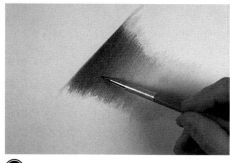

3 Continue to Darken

Now switch to a 2B pencil and repeat the process, again stopping at the halfway point of the previous scribble. You now have a smooth gradation of dark to light.

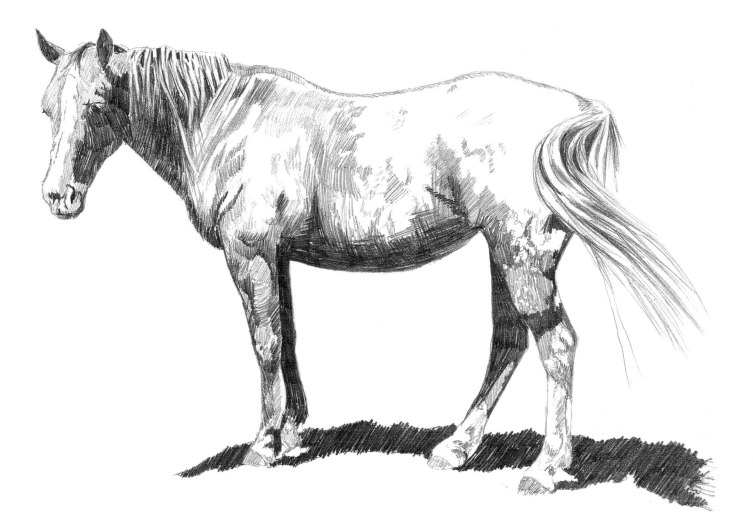

Putting It All Together

I used hatching and crosshatching extensively in this drawing. The finished work has more texture and is less smooth than what you get with other techniques. In areas such as the shadow under the horse, all the hatching goes in a single direction. In other areas, the hatching and crosshatching define the form of the horse.

Pssssst!

Whether you prefer to sketch using pencil lines, circular motions, scribble shapes or any other technique, that's fine. Don't let someone come along and say it can't be done using a certain technique. Exploring is how you develop your own personal style of drawing.

Smudging Techniques

To make your drawings look more life-like, you'll want to blend your pencil strokes for realistic shading. I call this technique *smudging*.

I remember taking a composite drawing class a number of years ago with an accomplished and well-known instructor. He paused at my desk and stared in horror as I smudged my drawing, finally grabbing the offending tool from my hand.

"Don't smudge!" he said. "You're grinding the graphite into your paper and you'll never be able to erase it!" He then walked away, taking my stump with him.

He was right. Smudging your drawing does indeed grind the lead into the paper, making it difficult if not impossible to "clean back out" to create the lights. I pondered his reasoning for the rest of the day before seeing the flaw in his point. Then it dawned on me that he was an oil painter, and oil painters work from dark to light. I am a watercolorist, and since watercolorists work from light to dark, we are used to preserving our whites or lightest areas beforehand. It's not a problem to use the technique of smudging for shading *if* you remember to keep away from the areas you wish to remain light.

I smudge my shading with some form of blending tool. These tools could be a paper stump, tortillion, chamois cloth or even a makeup sponge or facial tissue. Never, *never* smudge with your finger. Fingers contain oils that will contaminate your drawing and mess it up.

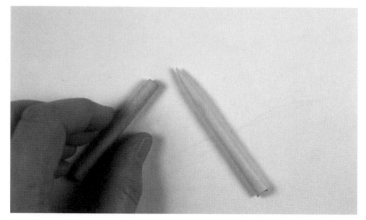

Small Smudging
Made of rolled paper, a tortillion is designed to be used on its tip, which will mash down if pressed too hard. This tool is meant to be used in small areas. It does not blend larger areas well because too much pressure is placed on too small a tip, creating a streaky appearance.

Large Smudging
A paper stump is typically used on its side, although you can use the tip for smaller areas. Don't hold it as you would a pencil, however, when blending large areas. Place the stump across your hand, as shown in the first picture, then turn your hand over to use the tool correctly. This spreads the graphite over a larger area without placing too much pressure on a small area.

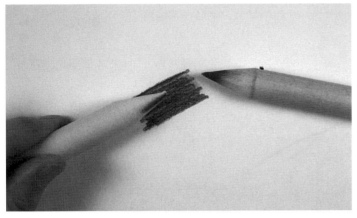

Getting Dirty

When you smudge, you are blending your pencil strokes together. The blending tool starts off clean and picks up the graphite from your pencil, smoothing and blending the strokes. You can accelerate this process by scribbling with your 6B pencil on a scrap piece of paper and rubbing your paper stump in the graphite.

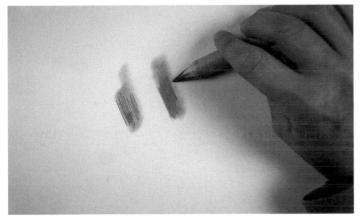

Start Neat

If your scribbles are sloppy to begin with, you will still see the sloppy strokes when you are done blending. Smooth, even strokes blend well together.

Pssssst!

When your paper stump gets dirty and dull from blending, you can clean it up and sharpen it with sandpaper. And if you accidentally mash down the tip of your tortillion, unbend a paper clip and use the wire to push the tip back out.

PRACTICE SMUDGING IN LAYERS

Using a paper stump involves shading in layers. Your goal is to go from darkest dark to light by blending in one direction. The darkest areas of your drawings will take numerous applications of pencil scribbles and smudging.

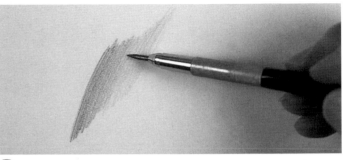

❶ Gently Scribble

Draw a line on a piece of paper. Gently scribble with a soft 4B to 6B pencil next to the line, putting less pressure on your pencil for gradually lighter lines as you work to the right.

❷ Smudge

Blend the scribble with your stump, using long strokes in the direction you drew in. Now draw your stump over an area that has no shading. The graphite on your stump will transfer to the drawing.

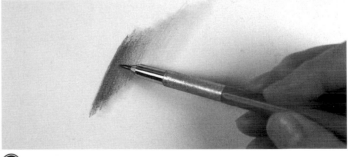

❸ Repeat

It will take several applications of graphite and smudging to adequately develop the darks in your drawing.

Psssssst!

Stay away from the "H" leads for smudging purposes. There just isn't enough graphite transferred to the paper to smudge well. Also, be a bit cautious of your paper stump transferring too much graphite. If it is too dirty, instead of creating a gently blended area, the stump will blob too much darkness onto your drawing. Do a practice smudge on scrap paper with your stump before applying it to your drawing to be sure.

Putting It All Together
The darker areas of this horse were blended together with a paper stump. Several applications of graphite built up the desired level of darkness in the darkest areas. No pencil strokes were used on the mid-tones; the shading came entirely from the graphite residue on the paper stump. Some lines were deliberately left showing to indicate hair.

Erasing Techniques

Your eraser is a remarkable tool. Although you've been erasing things you have written since at least the first grade, you've probably never truly appreciated it. Sure it can correct mistakes, like lightening a too-dark area, but its use can be so much more deliberate than that. In taking away graphite, an eraser can add tremendous interest to your artwork.

My two favorite erasers are the kneaded rubber eraser and the portable electric. If you haven't yet succumbed to the benefits of the portable electric, I suppose you could use a standard white plastic eraser. We'll also practice erasing with the help of an eraser shield.

Pssssst!

As children, we tended to think of erasers as mistake-fixers. They're far more than that. In art, we erase as much as we draw, using the eraser to create lights, lighten midtones and make texture (think wispy white hairs or wind-blown grasses). Look closely and you'll see that erasers were used extensively in the drawings throughout this book and often share equal billing with the pencils.

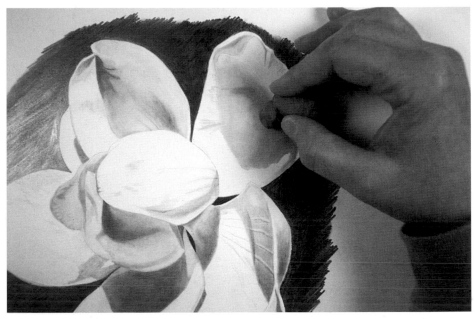

Kneaded Rubber Eraser
The kneaded rubber eraser will clean up mistakes just fine, but I love it because it will lift graphite from a drawing without leaving a harsh, unnatural edge. You use the eraser by dabbing—pushing it straight down, then lifting straight up—not by rubbing it side to side. The more you dab at a spot, the lighter it gets. This works wonderfully for developing the form of your subject (by creating light areas among darker ones) or for lifting out highlights.

Erasing Shields
Erasing shields are best used as a way to clean up small areas on your drawing. You position the shield so the shape that will best correct the problem is over the troublesome part of your drawing, then erase through it. Erasing shields are also useful for creating new shapes.

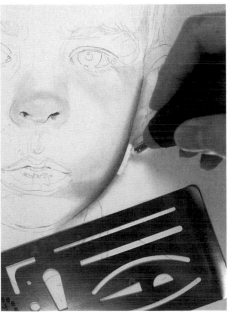

Outside the Lines
When I shade by smudging, I use a large erasing shield to clean up the outside edges of the subject. This allows me to make long sweeping strokes with the paper stump, which makes my drawing look smoother.

Give Templates a Try

You can create a variety of unique effects by making a custom template. Start with a piece of clear acetate, which you can find as transparency sheets or plastic report covers in just about any office supply store. Take a craft knife and cut out the shapes you desire in the sizes you want. Then you can lay the template on your paper and draw or erase the specific shapes through it. You can reuse these templates again and again for countless drawings.

Psssssst!

Custom templates are incredibly useful for the repetitious elements in a drawing. To avoid repetition that's too predictable (and therefore boring), change things up a little. Cut various sizes of the element on your template, or try flipping the template over and using the reverse image in areas.

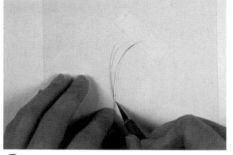

❶ Create the Shape

With a craft knife, carefully cut the template into the desired shape. In this case, the shape had a sharp point, so the acetate was reinforced with a piece of tape so it wouldn't tear.

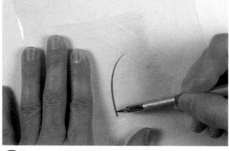

❷ Draw Through It

The template may be used to draw through to create a small, sharply defined area. It also could be used to build up a darker area on an already shaded area.

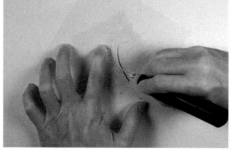

❸ Erase Through It

You could use the template like a custom erasing shield. It may be placed over areas that have been previously shaded to create layers of values (or lights and darks).

Draw or Erase With Templates
I used a small, curved custom template to draw in this blade of grass over a shaded area, then used the same template to erase a blade away.

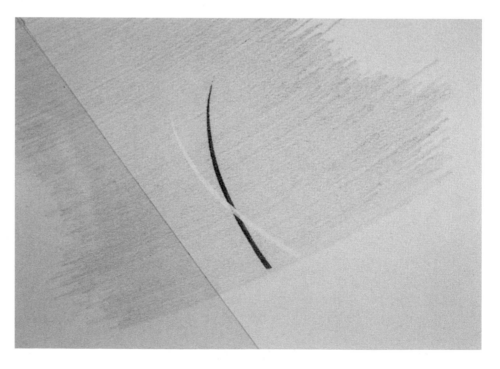

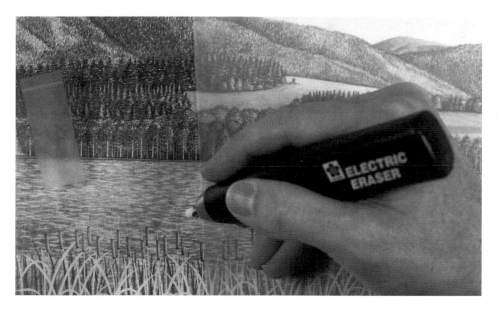

Putting It All Together
In this landscape drawing, the cattails, the tips and stems of the cattails and the trunks of the trees in the background were erased using custom templates. Some of the templates were reversed to create matching sides.

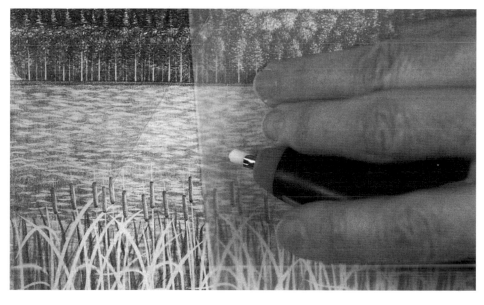

Look Closer …
The ripples in the water were also erased through a custom template.

Cheat Sheet

- *Contour drawing, in which you don't lift your pencil from your paper as you draw, trains your eyes and hand to move in sync and forces you to really observe your subject.*

- *Three common pencilling techniques for filling in your drawing are hatching, crosshatching and building.*

- *Hatching involves drawing parallel lines of varying lengths. Vary the distance between the lines to create lighter or darker areas.*

- *To crosshatch, layer sets of parallel lines over each other at different angles until you reach the desired darkness.*

- *Multiple pencils with different grades of graphite are required for building, a technique in which pencil tones are gradually layered.*

- *Blending or "smudging" makes your pencil strokes smooth and gives your drawings a finished look.*

- *You can blend using tortillions (ideal for small areas), paper stumps (best for large areas but usable in smaller ones) or household items like facial tissue, but never with your finger, which can deposit unwanted oils on your drawing.*

- *In drawing, erasers don't merely remove mistakes—they are used purposely to lift highlights, soften hard edges and create realistic textures.*

- *Erasing shields and templates can give you greater control in pencilling in or erasing shapes.*

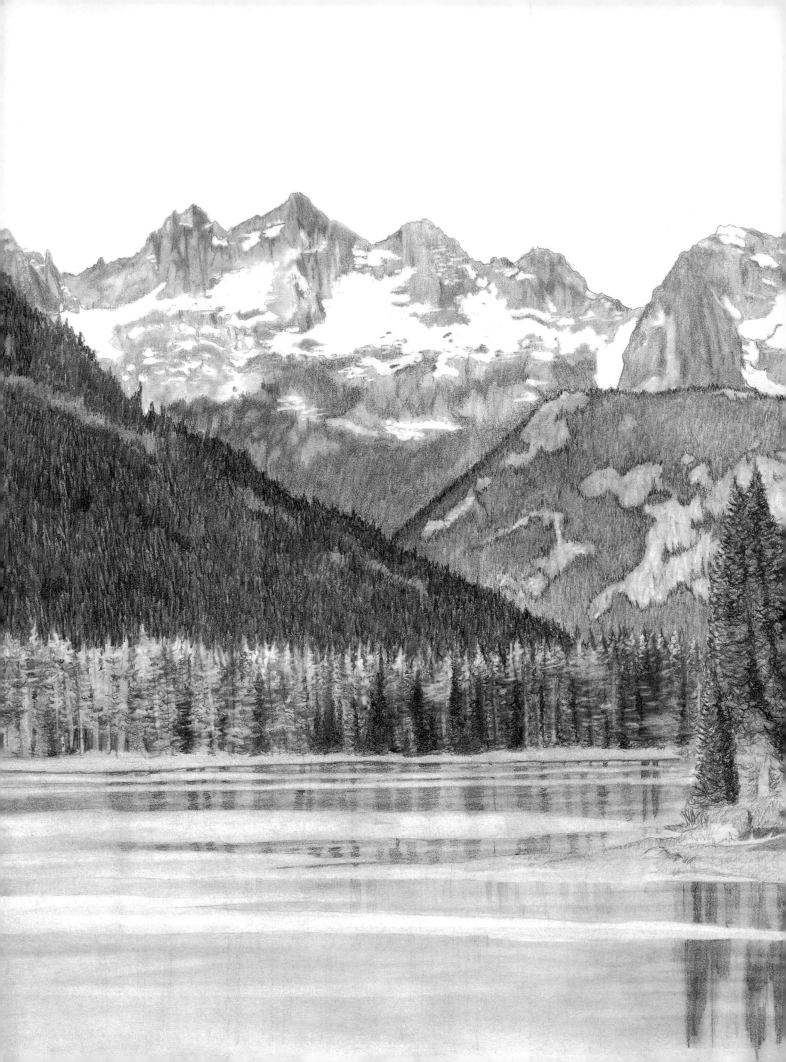

Site

Correct Site Helps Make Your Subject Recognizable
The exact location of each ridge and jagged mountain is not important if you're just inventing a scene. However, if you desire to draw a specific scene, such as this one of Cooper Lake in the Washington Cascades, you need to know how to properly scale and proportion those areas.

COOPER LAKE, WASHINGTON
Graphite on bristol board
10" x 8" (25cm x 20cm)

Site refers to the general location of the different elements of your subject on the paper. Tied to this concept is the idea of proportion or scale, which involves making those elements the correct size in relation to each other. For most artists, the drawing starts here. Once you've figured out how everything will fit, you can go about the business of developing the details.

Many artists get caught up with using only one technique to find the sites or locations of the parts of their subject. The grid method, for example, is a popular technique in which you divide a photograph of your subject into a grid of equally sized boxes that corresponds with a grid drawn on your paper. Then you re-create what you see in the photo, box by box. Quite frankly, life is too short to use a grid system for every drawing. I have some secrets to share on what works best in different circumstances.

Finding the correct scale and location for the various elements of your drawing often brings out such tricky terms as vanishing points, two-point perspective, horizon line and eye levels. Relax—we'll achieve all that with the simpler concepts of measuring, optical indexing and flattening.

A Lesson in a Jar

Among my regular activities I'm a professional speaker, and I sometimes use an illustration to make a point in my presentations. I'll take a clear glass jar and place four or five good-sized stones in it. Then I'll ask the audience if the jar is full. About half the group will say yes; the other half will stare at me as if I had sprouted horns.

Next I'll add smaller stones, filling the jar further. I'll ask the question again: "Is the jar full?" This time seventy-five percent will respond with no, anticipating another clever move on my part, and the remainder will fold their arms and stare at the ceiling. I'll pour sand into the jar next and repeat the question. Ninety per-

cent will say no, and the remaining ten percent will check their wristwatches. Finally, I'll pour water into the jar. "Is the jar full?" I ask. By now the entire audience has been snagged by my antics. Yes, they all admit, the jar is finally full.

The point is this: if I don't put in the big rocks first, they'll never fit. As a budding artist, you need to get the big stuff down first. Work from the large, overall shapes to smaller, specific details. I can't emphasize this enough as you continue through the chapter: no amount of spectacular detail can "fix" a drawing whose main shapes aren't placed correctly.

Don't Sweat the Small Stuff ... Yet
The next time you're in a hurry to get to the details of a drawing, remember this jar of rocks!

FIRST THINGS FIRST
Graphite on bristol board
14" x 17" (36cm x 43cm)

The Art of Measuring

You already have a basic knowledge of proportion and scale. You know about it because you learned it, and examples of it surround you in your everyday existence. You learned that a cocker spaniel is a very small dog when compared to an Irish wolfhound, but not so small compared to a chihuahua. You learned that you'd better measure the rooms of a new house and all the furniture you'd like to fill them with if you expect everything to fit. You learned that a large milkshake isn't that much bigger than a small one (that is, until your bathroom scale sets you straight).

So, what did you actually learn? You learned to compare things to other things through measurement, whether by eyeballing it or getting on your hands and knees with a tape measure. This is how we check proportion or scale—the size relationships between objects. In art, you will use measurement to put the proportions within your drawing to the test.

What Can Be Used as a Baseline?
Anything that is smaller than most of the objects in the drawing makes the best baseline. For example, the diameter of the quarter may be compared to the length of the key: the key is about twice a long as the quarter. The diameter of the quarter may also be used to measure the length of the screwdriver.

Baselines and Why You Need Them
In correctly drawing an object to scale, one technique is to establish a baseline and draw from that. A baseline is a common term used to describe the standard to which we compare something. After all, size is relative to what is being compared. A ruler is really a type of baseline, because we use it to measure linear objects.

In drawing, you will compare a baseline in the image in front of you to something else within the same image. For example, the width of a window in your reference photo might be a baseline. The building the window belongs to may then be considered about five windows wide, and the trees surrounding it about two windows wide each. Baselines are especially handy when drawing people. Drawing the width of the face, for instance, is much easier when you think in terms of how many "eyes wide" it is.

Early Lessons in Site
You've already had quite a bit of experience evaluating and adjusting proportion and scale. Think back to penmanship class in grade school: You learned there was an appropriate size and location for words on your lined paper.

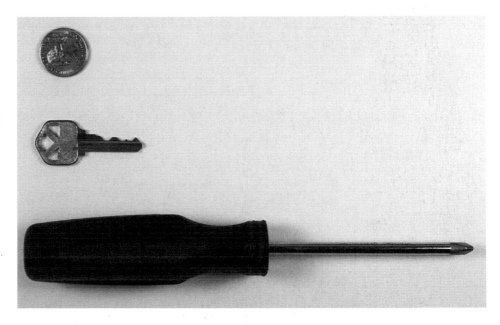

Simple Measuring and Enlarging With Photos

The easiest way to measure objects with a baseline is to use a photo. Photos are two dimensional and easy to manipulate with your ruler or measuring tool. Measuring the proportions in your reference photo not only helps ensure that your drawing will be accurate, but it allows you to enlarge your drawing with ease.

A simple measuring system works best when the image is, well, simple and consists of mostly straight lines. Take the windows and door of a building, for instance. Since we are dealing with all fairly straight lines, a ruler works just fine for establishing proportions. We might find the window is 2 $\frac{7}{16}$ inches wide, so we draw a line on our paper that is 2 $\frac{7}{16}$ inches wide. The ruler measures it out for us. No big deal. Boring, but not hard.

But what if you wanted to make your drawing two and a half times bigger than the photo? You could do the math. Let's see, two and a half times 2 $\frac{7}{16}$ equals—well, maybe the math was a bad idea. Sure you could simply round your numbers up or down for easier arithmetic, but do you need to number crunch at all?

There is an easier way, minus the math. All you need besides your reference photo and drawing paper are a thin scrap of bristol board, an HB pencil and a ruler.

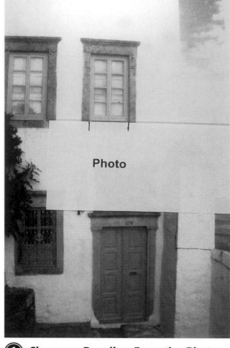

① Choose a Baseline From the Photo

Make a cheat sheet. On the scrap paper, write "photo" on one end and "drawing" on the other. This is to remind you to use the photo measurement to measure the photo and the drawing measurement to measure the drawing. You may think this is overstating the obvious, but you still keep forgetting where you left your car keys, so there's a remote chance you'll forget which side measures what. Select a short, straight part on the photo (we'll use the inner part of the window) and mark that width on the paper.

② Create a Baseline for the Drawing

You can choose any size for your drawing: a smidgen bigger, smaller, twice as big, whatever. Decide how big you want to draw the image and, on your cheat sheet, mark what will be the width of the window on your drawing.

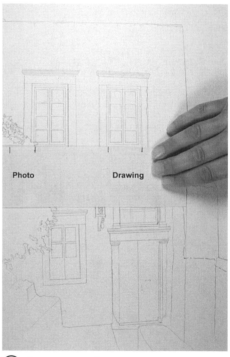

③ Compare and Measure as You Draw

Start your drawing using this as a baseline or standard of measurement. Everything in the picture is either the same size as, smaller than, or larger than your measurement. With your one baseline and piece of paper, it is possible to scale everything in the photo to the size you need it to be for your drawing.

Measuring Curved Subjects

Measuring objects with straight lines is fairly straightforward, but what happens when you must measure something with curves? In my experience I have found that many beginning artists, and a few experienced ones, have a consistent problem drawing curves correctly. Curves can be tough to master. A curve that's too flattened will make something look incorrectly enlarged. Too rounded a curve will "squish" your drawing. Let's look at two subjects containing curves and use the same technique to measure both.

Pssssst!
A small confession here: I draw first and use the measuring system at the end or midway through to check how well I've scaled out the drawing. It's faster than measuring ahead of time and it trains my eye to pay attention to scale.

baselines

Exercise #1
My brother Scott was very unhappy that his mug didn't make it into my last book, so we'll use it in this one. To measure the curve of the side of his face, first select a baseline, which should be a fairly small shape on the face. In this case we'll use the width of his eye. Mark the width on a piece of paper, then see how many eye widths it takes to get to the side of his face from the curve of his chin (about one and a half eyes). Now turn the paper sideways and see how many "eyes" it takes to get to the widest point on the side of his face (three-and-a-smidgen eyes). The side of his face, therefore, will curve between these two points.

Exercise #2
This time we'll measure a baby carriage. Take a smaller measurement for the baseline—say, the width of the wheel—and compare it to where the carriage curves around in the front. It's one "wheel" out and one "wheel" down. That was easy!

Getting the Angles Right

This next measurement exercise is a bit more challenging. Our goal is to correctly proportion our drawing of a building structure and have it show the same angles as the reference photograph. It involves the same process of measuring that we used in the previous example, but we have added perspective, the idea that the structure has depth and parts of it appear closer to us or farther away.

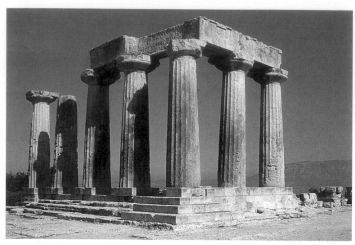

Reference Photo
Let's figure out how to accurately draw the angles of these ancient columns in Corinth, Greece. When doing this with one of your own photos, work on a photocopy instead of marking it up.

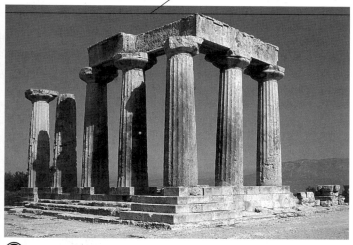

horizontal reference line

1 Draw a Reference Line

Using your ruler, draw a line across the top of the structure on the photo. This line touches the highest point of the columns and runs from one side of the photo to the other. This gives us a reference line from which to measure. Lightly draw a corresponding line across your drawing paper. We will be erasing this guideline later.

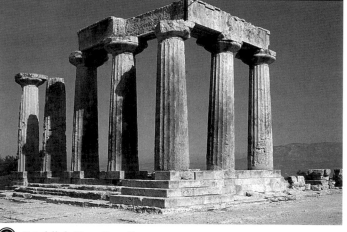

horizontal reference line *photo baseline*

2 Establish Your Baseline

We need to select a baseline measurement from the columns—a short, straight area that we can use to measure the entire drawing. I chose the height of the near corner as shown. Mark a piece of scrap paper with this measurement.

Psssssst!

A straight line is an artist's best friend. It provides a concrete reference point that assists our eyes in recognizing even the most subtle angles and curves of our subject.

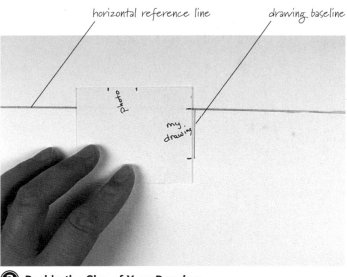
horizontal reference line drawing baseline

③ Decide the Size of Your Drawing

If you want your drawing to be the same size as the photo, simply transfer the measurement to your paper. If you want it to be larger, make the baseline slightly larger when you transfer it, as I did here. If you want to make your drawing smaller ... you get the drift.

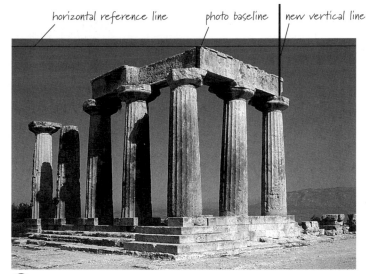
horizontal reference line photo baseline new vertical line

④ Add a New Vertical Line

Draw a vertical line at the end of the columns on the photo. Make sure it is parallel to the photo baseline. The correct angle of the columns is now bracketed between the lines. Measure the distance over and down on the photo; that is, from the top of the photo baseline (at the near corner of the structure) straight across to the new vertical line at the far corner, then from this point down to the top of the far corner. The horizontal distance is almost four baselines, and the vertical is about one and a half baselines.

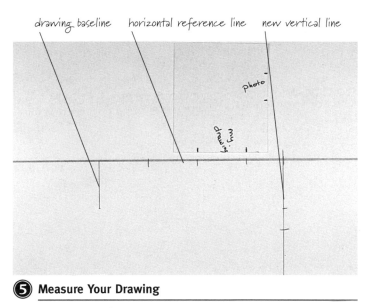
drawing baseline horizontal reference line new vertical line

⑤ Measure Your Drawing

Using the drawing baseline, measure the same amount of baselines over and down on your drawing. Make a mark at almost four baselines over and one and a half baselines down, and you have the correct reference point for your angle.

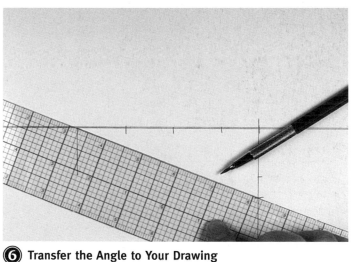

⑥ Transfer the Angle to Your Drawing

Use a ruler to connect the points and form the correct angle. The stone in the photo is not a perfectly straight line, but for now a ruler gets us in the ballpark.

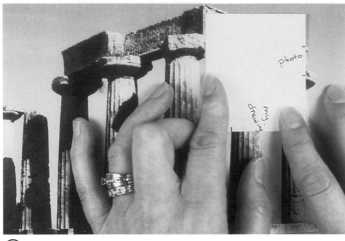

⑦ Don't Assume

Don't assume that the far corner of the entablature (the block held up by the columns) is the same height as the corner nearer to the camera. Measure. When I did a comparison measurement, the far corner was slightly smaller—which makes sense, since things appear to be smaller the farther they are from you.

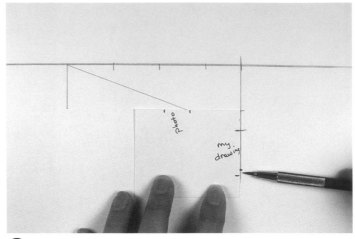

⑧ Compare and Mark

Measure your drawing with a slightly shorter mark than the drawing baseline to indicate the height of the block.

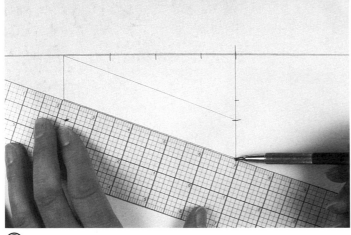

⑨ Finish the Angle

Connect the dots and voila! You have correctly recreated the angle in the picture for your drawing. Now the entire drawing may be scaled by using your baselines and measuring.

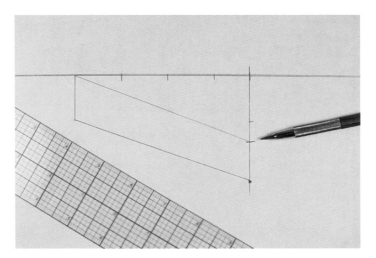

Psssssst!

Any baselines or other lines of reference should be drawn very lightly. Seeing these guidelines in your finished work is kind of like noticing someone's wearing a beautiful new shirt, then seeing that they forgot to remove the price tag!

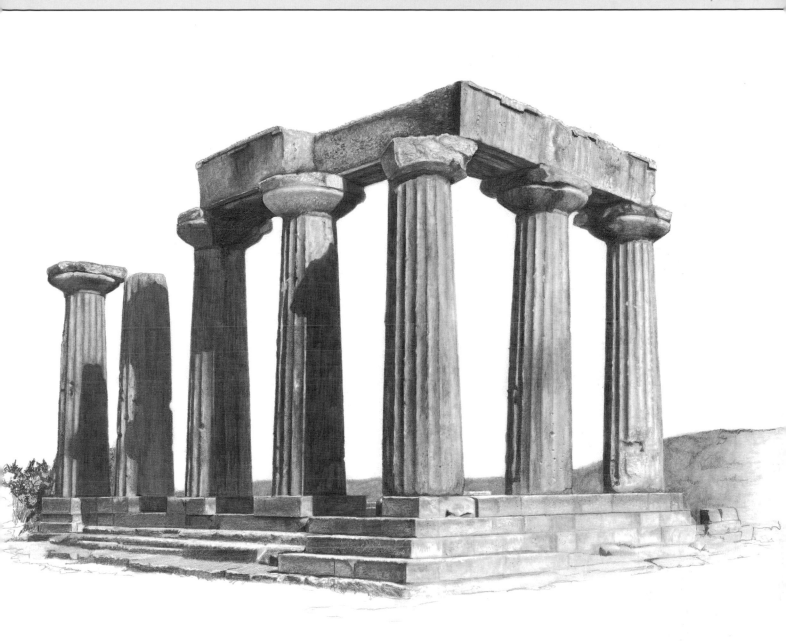

Then a Miracle Happens ...

Okay, so a couple of lines on a piece of paper does not suddenly morph into a drawing like this. It's a good start, though. If you can get the angles and proportions correct, you've achieved the first step and laid an excellent foundation for your finished drawing. We'll work on honing your eye, clarifying your drawing and creating realistic shading as we progress through the rest of this book.

CORINTH, GREECE
Graphite on bristol board
14" x 17" (36cm x 43cm)

Flattening

Having just shown you how to measure something on a two-dimensional photo, let's touch on measuring something "on the hoof" as it were. The next site technique we'll look at is *flattening*.

What if a fantastic elk stepped out in front of you while you happened to be on a nature hike with your sketchbook? This very accommodating elk strikes a pose and holds it long enough for you to sketch him at your leisure. Okay, this scenario may seem a little far-fetched, but you need to know how to work out the proportions in a three-dimensional situation no matter what your subject is.

Working out proportion in three dimensions is a lot like working in two dimensions. Two-dimensional objects have height and width. What is a three-dimensional object? One with depth. How do you perceive depth? By looking at something with both eyes. But when you are drawing something on a two-dimensional piece of paper, you don't want that depth perception. So what do you do?

Close one eye. One eye on its own will not perceive depth. Closing one eye will flatten the world around you and help you draw a three-dimensional object on your two-dimensional paper.

Don't believe me? Try this: Open both your eyes and place your finger in front of your face. Look beyond your finger at the background. Your eyes will actually see two fingers, and you can't see both your finger and the background at the same time. Now try the same thing with one eye closed. Aha! One finger and a background.

Let's look at how to establish a baseline on that three-dimensional, ever-so-patient elk.

① Select a Baseline on the Subject

Choose a portion of the subject to use as your baseline. Remember, it should be a fairly small line, either vertical or horizontal, because a smaller line will be easier to compare to everything else in your drawing.

② Measure the Baseline

We'll select the height of one antler as our baseline. Extend your arm fully and straight out in front of you and close one eye. Hold your pencil so that it's parallel to your body. Use the tip of the pencil to mark the top of the antler. Use your thumb to mark the bottom of the antler. This measurement is your baseline.

③ Compare the Baseline Measurement to the Subject

Using the measurement of the tip of the pencil to your thumb, you can now compare the antler baseline to any other part of the elk. For example, you may discover that, compared to the antler, the elk is about four baselines long.

baseline

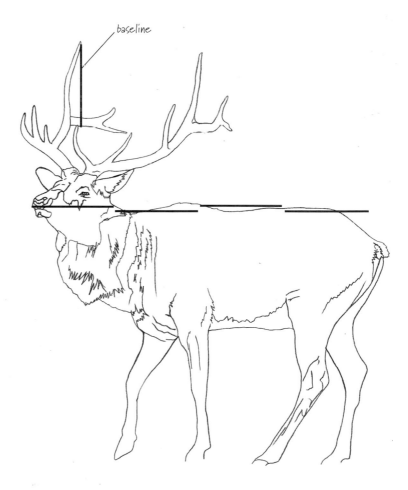

Optical Indexing

Optical indexing is a fancy way of saying things line up. The idea is that if you have one object in your drawing placed correctly, you can use this as a point of reference to check the locations of everything else in your drawing. If certain parts of your drawing line up or are spaced appropriately according to your drawing reference, then you have a correctly proportioned piece of artwork.

Many artists use either a few simple horizontal or vertical lines or a more thorough grid system to check the alignment of the elements within their drawings. Both methods make it easy to spot mistakes in placement and proportion. Some artists begin their drawings with these guidelines to prevent problems from the get-go; others pull them out when they are in the middle of a line drawing that's not quite right. How you decide to use them is entirely up to you.

Bring On the Grid
Many artists use grids, but they are labor intensive and not needed unless it is a complex image you desire to draw. This pile of cats is a complicated series of shapes. This is a good time to use a grid system.

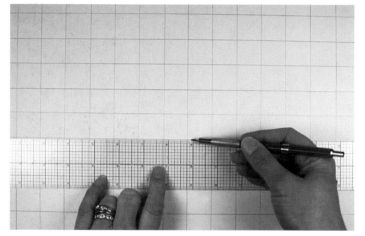

Draw the Squares
Place a grid of equal-size squares over the reference photo, or draw one directly on a copy of the photo. Then draw a grid of equal-size squares on your drawing paper. If you use a grid of one inch by one inch (3cm x 3cm) squares on your photo and the same on your drawing, the drawing will be the same size as your photo. For a larger drawing, make a larger grid on your paper.

Fill In the Squares
Draw the shapes you see within each square. Keep your finger (or other marker of some kind) on the reference-photo square you're currently working on so you don't get lost. (It may sound silly, but there are kitty paws and tiger stripes going in all directions.) Once you have the shapes drawn in, carefully erase your grid. Looking at the various parts of a complex subject in this way makes drawing them much more manageable.

Psssssst!

You can make a reusable grid in a variety of different ways:

- *Create a grid on a computer and print it on a sheet of clear acetate.*
- *Draw a grid with a permanent marker on a sheet of clear acetate.*
- *Draw a grid on regular paper, run it through a copier and make copies on acetate.*
- *Make a grid on a clear insert or folder, and slide your photo into the insert.*

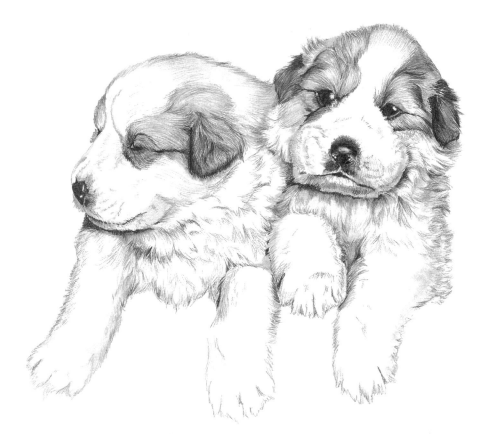

Check Locations

For example, when I place a horizontal ruler under the jaw of the puppy on the right, it lines up with the top of the left puppy's nose.

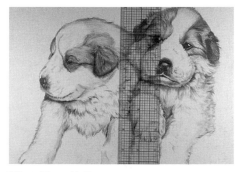

What Lines Up?

Here we find that the inside corner of the right puppy's eye lines up with the edge of his nose. Choosing a few different features or parts of your subject to spot check is usually enough measuring to make sure your drawing is in correct proportion.

Reading Between the Lines

These two Great Pyrenees puppies are much less complex than the pile of kittens. A grid could be used, but often just a few lines are necessary to measure the distances between elements to make sure you're in the ballpark. Try drawing these puppies first, then take a ruler and see what lines up in your drawing compared to mine.

Cheat Sheet

- *No amount of spectacular detail can "fix" a drawing whose site, or location of shapes, is incorrect.*

- *Every drawing needs a baseline or standard of measurement to which all the other parts of the drawing are compared. This ensures correct proportion.*

- *Measuring elements according to a baseline is easiest to do with a photo because it is two dimensional.*

- *Establishing two baselines—one for your reference and one for your drawing—makes it easy to enlarge or reduce the elements for a larger or smaller drawing.*

- *Make a horizontal reference line to help you check angles for accuracy.*

- *To measure a three-dimensional subject, "flatten" it by looking at it with one eye closed, extending your arm straight out in front of you, and measuring a baseline with your finger.*

- *If certain parts of your drawing line up or are spaced appropriately according to your drawing reference, then the drawing is in proportion.*

- *Use a complete grid or just a few horizontal and vertical guidelines to check how the elements in your drawing line up.*

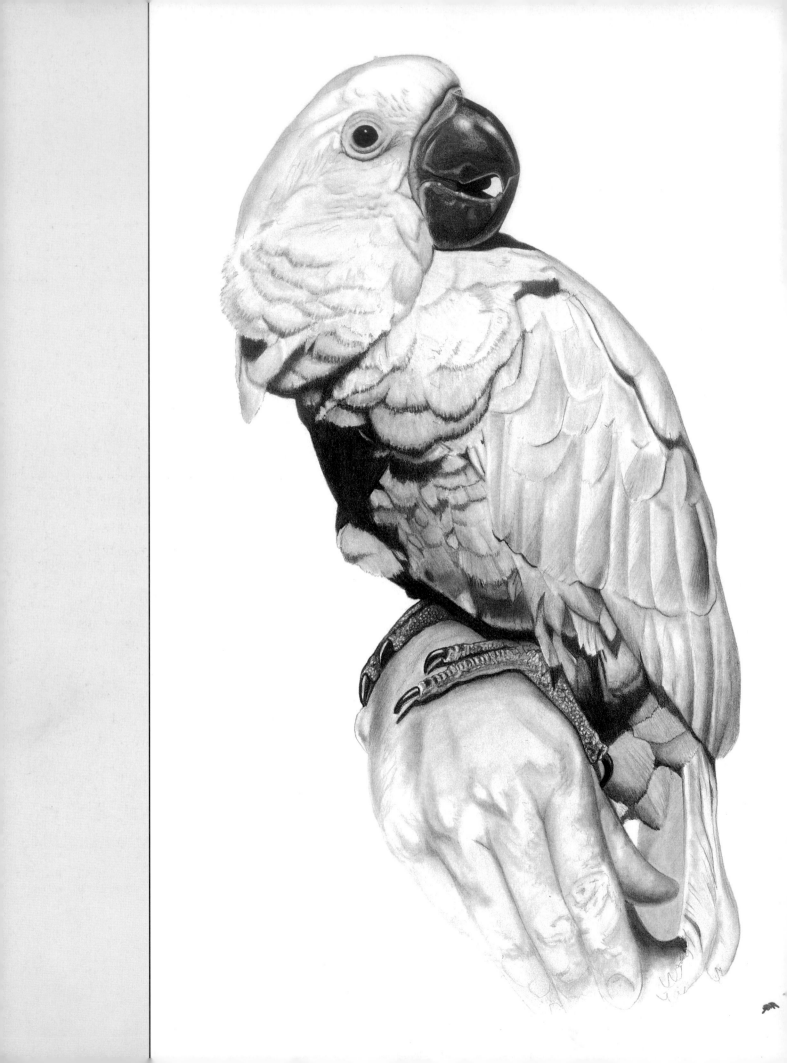

Shape

Think Shapes, Not "Stuff"
The feathers in this drawing of a Moluccan cockatoo were not thought of as feathers, but rather as shaded curves. You may think you can't draw feathers, but curves are simple.

HOGAN
Graphite on bristol board
17" x 14" (43cm x 36cm)

We tend to see shapes around us without really paying attention to them. For example, you use the ability to recognize shapes in order to read and write. Of course, because our mind isn't really paying attention as we read and write, at least not to the shape of the letters, we're not aware of the automatic processing going on. Instead we are focusing on the thoughts and ideas expressed by the words.

In a sense, it's the same with drawing. We see the subject—a landscape, a face, a group of flowers—but we are focused on the ideas the image suggests. The nostalgia of the place, the love of the person, the beauty of the garden. As artists, we must push away, at least for the moment, our ideas and thoughts about the subject and focus on the mechanics of the subject.

Shapes are recorded in our subconscious, but to draw those shapes, we need to bring them into our conscious mind. Doing this takes concentration and focus. You must make your brain slow down and pay attention. In our fast-paced, high-speed, drive-through society, this is a foreign concept. The world is rich in information, and we are on data overload. The tools presented in this chapter will assist you in training your mind to slow down and pay attention. Use one or more of these tools (more is better!) to help identify and draw the shapes around you.

Seek to Simplify

Most children find they have the ability to make simple drawings that satisfy them. Popular with this young set are cartoon characters. They often graduate from drawing such animated friends as the Little Mermaid to the exaggerated comic book superheroes. Then … nothing. Their art interest often drops off. What happened? It could be that football, girls, boys, dances, music and life in general takes over, and they simply move on to other new and exciting pursuits. I suspect that is often the case, but I also think that once their interest in comic-strip characters wanes and the budding artist wants to try drawing something else, it proves to be difficult and they simply give up.

It was easy for the untrained eye to find the well-inked outlines of the cartoon characters and comic book images. The black-inked edges made the shapes of objects easy to see. Unfortunately, the world around us is not outlined in black. It's more subtle and the shapes are harder to see. When something is more demanding, many move on to other subjects or interests.

Artists continue to seek those same simple shapes. It's really not so hard, because no matter how "decorated" they are, shapes are basically either straight or curved.

Humble Beginnings
When we were children, most of us at least made an attempt to draw our favorite cartoon characters. We grabbed a crayon or marker and started drawing lines, imitating what we saw.

Artistically Advanced
Winnie has no hard edges and certainly no black outlines. In fact, she's actually somewhat outlined in white. The basic shapes in both the cartoon drawing and this one are essentially the same, even though they aren't quite as obvious to the eye in *Winnie*.

WINNIE
Pastel pencil on toned paper
20" x 16" (51cm x 41cm)

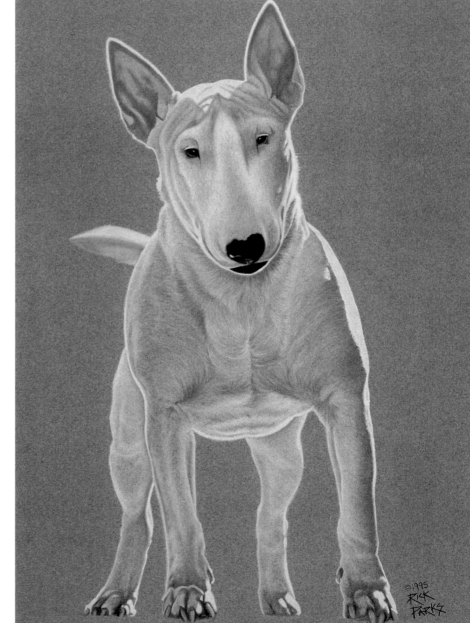

Rename What You See

It's really not enough to say you see a shape such as those clearly shown in these pictures. Artists think of the objects they are drawing in terms of shape. They think about drawing circles, curves, straight lines and so on. If you asked them to say aloud what they were thinking as they drew, it would be phrased in terms of the shape, not the subject itself. Changing the way you think and name something will help you see it better for the purposes of drawing.

Take your camera out and record some of the shapes around you, or dig through your old pile of reference photos. Select a photo and draw its shapes—and *only* the main shapes, not all the details. The contour drawing exercises you learned in chapter three are perfect for training you to see and draw the shapes of things.

curves

round shape

straight lines

partial triangles (or acute angles)

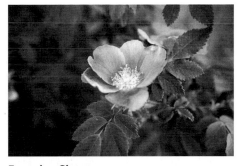

Everyday Shapes
Look at the simple shapes found in this photo. Don't think "flower" as you draw; think straight and curvy lines, round and angular shapes.

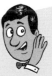

Seeing Patterns, Not Things
Photos like these are exceptionally good for helping you understand how to look past subject matter and see only shapes. An artist is more interested in the patterns in these pictures than the fact that they show columns and palm fronds.

Pssssst!
Don't fall into the rut of drawing all trees, rocks, flowers and so on the same when they are not. To help avoid this, describe what you are drawing in terms of its shape. This will help you recognize the things that make it unique, which will in turn make for more realistic drawings.

Isolate Parts of the Whole

Just as a musician may practice a portion of a melody and a dancer may practice the same movement over and over, an artist often breaks up a subject such as a human figure and draws just the hands, feet or facial expression.

Isolating and studying shapes is very important. I don't know how many times I've looked at a drawing or painting that was well shaded and fairly well proportioned, but the trees were badly rendered on a landscape, the eyes were incorrectly drawn on a portrait or the nose of a dog looked like a double train tunnel. Take apart the subject you wish to draw and look at its parts. Separate them and draw them in individual sketches. Make it a habit to carry your sketchbook with you and work on these little studies to improve your overall drawing.

Pssssssst!

Cut a square out of the center of a piece of white paper and place it over your reference photo. Move the paper around the photo to force your eyes to focus on the shapes in the particular area shown.

Where Do I Start?
One look at this cat and many beginning artists would be too overwhelmed to even consider drawing it.

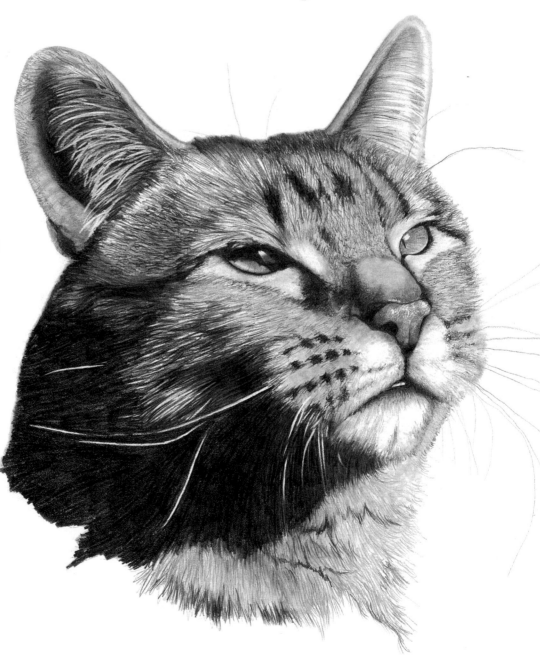

There, Now That's Not So Bad ...
The cat seems manageable when you try drawing just an eye or the nose before attempting to render the entire head with all its features and fur patterns. Along with the view shown in the full drawing are views of the cat's left eye and nose from slightly different angles. Isolating the cat's features like this helps you recognize the subtle differences these different points of view create.

Recognize How Shapes Relate

The dictionary defines "relate" as bringing into logical or natural association for a reference. We have been using a form of relating every time we draw a line next to the subject. We relate the subject to that line.

I came to realize that I was using another technique similar to drawing a line for reference—I was also using a circle for reference. A circle has certain properties that I can count on, much like a line. I can use these properties to help me see to draw.

You can use any circular shape in your subject to help you see the correct placement of other shapes. Using a circle as a point of reference can help you draw better.

Looking Round
It's pretty easy to determine the midpoint of a circle. If I were to fill in this circle to the halfway point, I would simply fill in to the fattest part.

Lines and Circles
Stay with me on this one—we're going somewhere. If I see a line that crosses the circle, I can determine where to place that line in a drawing by using the properties of the circle. A line through the center is easiest to duplicate because the line crosses at the fattest part. Lines in the top third area, bottom fifth area and so on cross the parts where the circle is getting smaller or larger, respectively.

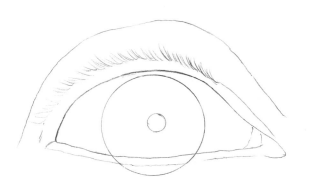

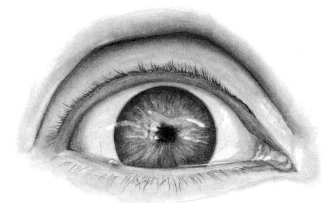

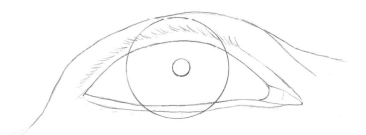

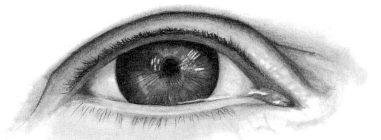

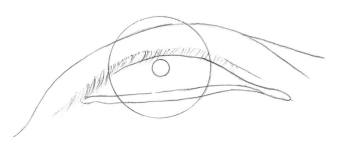

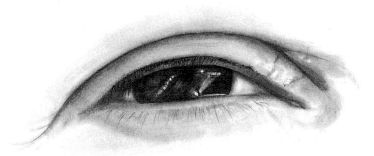

The Eyes Have It

Let's apply what we've learned to a familiar object. I find using a circle for reference most useful when drawing eyes. When I look at an eye, I look at the perfectly round iris (the colored part) to determine where the eyelid should go. The location of the lid gives the eyes their expression, and if it's located at the wrong spot, the look is off.

Compare by Measuring

We addressed measuring in the last chapter where we looked at how something can be compared to something else. The same holds true of measuring and comparing the shapes within a subject. Once again, if it is in front of you, whether in a photo or in person, you can measure it. All you need is to choose a baseline, a standard measurement by which all else is measured. Pick something fairly small, with a clearly defined beginning and end, that can be measured with a straight line.

Remember, Everything's Relative

Learning to draw is a process of training your eye to see the things in front of you. Okay, so I'm repeating myself, but there is an important word in this sentence: process. It doesn't happen overnight. You can't go to bed with a drawing book under your pillow and expect to draw well the next day any more than you can put a diet book under your pillow and wake up thin. I know, I've tried it!

There is a subtlety to angles that takes a practiced and trained eye to see. We need clues to tell us that something is not exactly level in front of us. Think about hanging a painting or photo on the wall. How do you know if it's straight or not? The blankness of the empty wall around the painting provides no feedback. To guide us, we look at the line where the ceiling and wall join, or the level of the floor, and determine the level of the art. I'll admit some folks actually use a leveling gizmo to help, but for the rest of us, it's the old comparison system. We step back, eyeball the painting, compare the top edge to the ceiling and adjust.

It's the same concept in drawing. It's easier to make a relative judgment about something than an absolute judgment. It's easier to say a work of art is level

compared to the ceiling than by just looking at it. It's easier to describe something's exact color, say red, as compared to a red shirt that someone is wearing than to describe a shade of red without a starting reference.

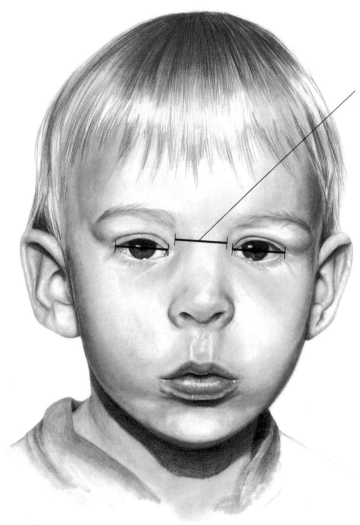

The space between the child's eyes is about one eye width.

A Baseline for the Face

The eye is a good choice. Its width is usually clearly seen, can be measured from inside corner to outside corner, and is small enough to be used to measure the different parts of the face.

As I focus in on smaller details, I can choose another baseline to delineate more information on the drawing. For example, the width of the iris (the colored part of the eye) may be compared to the width of the entire eye.

ETHAN STUART
Graphite on bristol board
17" x 14" (43cm x 36cm)

Ask Questions

I discovered this tool coming home on a long plane trip. A young boy, about ten years old, sat next to me, drawing pictures on a sketchpad. I asked him if he wanted a drawing lesson. He agreed, so I took the magazine I had been reading and found a photo of a lady walking on a windy day. I placed my finger on her head and asked the young man, "What shape is this?"

"Oval," was his rather smart response.

"Draw an oval," I said, and he sketched the oval. I placed my finger on the edge of the lady's neck and said, "What is this?"

"It's a straight line," he replied.

"Is it straight to the bottom of the page?"

"No, it stops and goes in a different direction."

"Where does it change direction?"

"Across from the bottom of her chin."

I continued moving my finger around the woman's outline while the boy verbally identified the direction and length of each edge before drawing it. When we were done, the creditable drawing was completed.

Several things happened in this exchange. My finger on the photo helped him "keep his place" on the image, much like small children will place their finger on the words of a story as they read. Secondly, I was training his eye to see the relationship of shapes without drawing lines. When he told me the neck of the woman started at a particular point on the head and ended at the chin, he had successfully identified the length of the neck by using another part of the head. Additionally, he was forced to articulate the drawing, which made him focus, concentrate and understand what was happening.

Now, most artists don't sit at their sketchpads muttering, "Okay, now the line goes down and to the left and …" while they trace the image with their finger. Their eye naturally finds the relationships and keeps its place, just as most adults no longer use their finger and move their lips when they read. For those just learning to draw, however, this technique may help you draw better.

Articulate Out Loud What's Happening
I started at the bottom of the stairway wall for no particular reason. This edge goes up and at an angle. It does not go off the paper; it stops and something else happens. Ask yourself what happened (the edge ended), what else is going on at this point (the ledge at the top of the steps begins) and in what direction does something occur (a horizontal edge begins). Does the new horizontal line go on forever? No, it too ends when it begins the edge of the third line, which now goes straight down. This internal conversation causes you to really analyze, in terms of the formed shapes of the subject, what you are drawing.

Be Aware of Negative Space

No, this is not a New Age reference to a place with bad vibes. Negative space is the area around and between the positive shapes that you tend to devote most of your attention to when you draw. If I'm drawing my hand, for example, the hand is the positive shape and the spaces between my fingers and around my hand are the negative spaces.

Negative space and positive space work together to form the whole of the image. I'll admit that sounds like the most obvious thing in the world. I stated it because what it means is that if I observe and draw the negative space, the positive shapes will be correct as a result. They don't have a choice. Aha! That means by concentrating on the negative space when I draw something complicated, the positive will be correctly drawn and properly proportioned.

Pssssst!

One tool that helps artists more easily identify negative space is the viewfinder. A viewfinder is a square piece of cardboard with an open middle, or you can make an adjustable one with two L-shaped pieces. Viewfinders help you define edges and see relationships.

Think Negative, Not Positive
The negative space around this elk does much to define its form.

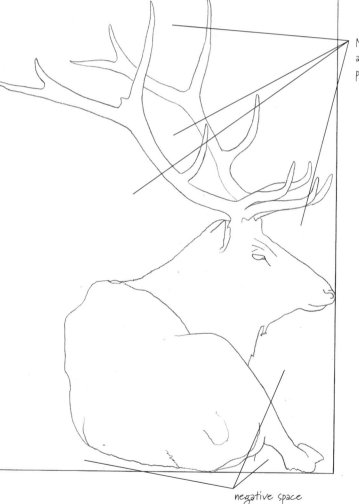

Negative space exists around and between the parts of your subject.

negative space

74

Invert Your Drawing

Whenever I teach my drawing classes, I position the students in a "U" shape and I stand in the middle of the "U." This means whenever I assist a student in her drawing, I'm looking at it upside down. Students are initially convinced that I'm a supremely gifted artist because I can immediately spot the problem in their sketch, despite the view. What they don't realize is that it's often much easier to see something more accurately when it's inverted, or upside down.

You're thinking, sure, right, whatever you say. It's true, though: When something is upside down, it looks weird (profound thought). If it looks weird, your brain can't make assumptions, place preconceived patterns and otherwise shut out the reality of what you are viewing. In a sense, you are slowing down your brain and forcing yourself to focus on what is really in front of your eyes, not what you merely *think* is in front of your eyes.

If the inversion tool is so eye-opening, why not just use it from the beginning and make your line drawing upside down? The answer is because it is hard—very hard and frustrating. You can get pretty lost when trying to draw from an upside-down photo. Inverting something to draw it works better if you are attempting to copy a line drawing like the one on this page as opposed to a photo. However, the best time to use this tool is after you've made your drawing. Once something is drawn using a reference photo, inverting both the drawing and photo helps us see the corrections we might need to make.

Reference Photo

A Whole New View
Turning a line drawing upside down like this will help you see your subject as a bunch of shapes rather than the familiar image. Try recreating this line drawing upside down as shown here to see what I mean.

Compare by Tracing

We have a cat named Big Fat Kitty. She doesn't seem to mind the name, which she earned because she is, well, a big fat kitty. This is not a subjective judgment. Objectively, Big Fat Kitty, when compared to the other cats residing with us, is at least ten pounds heavier.

It's not unusual for us to compare one thing to another. We use many comparison systems in art as well. Let me share another comparison technique that will help you draw better.

Often your brain has trouble pulling one particular feature out of a complicated background. Have you ever despaired over not being able to draw the lips correctly on a portrait, or get the angle of a building's roof just right? If for a moment you can look at the lips apart from the rest of the face, or study the roof apart from the remaining structural elements, your task will be easier.

You've probably always been told that it was cheating to trace something.

Tracing the shape, however, allows you to see that shape in its simplest expression, separate from its busy surroundings. To try this technique, you'll need a piece of tracing paper, the original photo you're trying to draw and your somewhat-completed drawing.

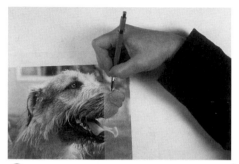

① Trace Over the Photo

Place a piece of tracing paper directly over the photo and trace the troublesome shape.

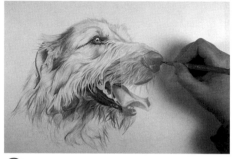

② Trace Over the Drawing

Cover the shape you've just traced with your hand. No peeking! Place the same piece of tracing paper over the pesky problem area in your drawing. Trace it so that the two tracings will end up side by side.

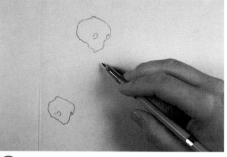

③ Compare the Tracings

Look at the two tracings. Subtle differences in shapes become very apparent when simplified into a line drawing and removed from the busy background.

 Pssssssst!

Tracing paper is a fantastic multitasker. Not only can it help you work out problematic shapes, but if you place it beneath your hand as you draw, it will keep you from inadvertently smudging those shapes in your finished drawing.

Flatten the Three Dimensional

In chapter four you learned how to visually flatten a three-dimensional image to make it easier to draw on your two-dimensional paper. This technique is helpful whether you're sketching the overall scene or focusing on one particular part or shape.

Visual Flattening for Easier Drawing
We can visually flatten three-dimensional objects in front of us to make them easier to draw. Even though a bottle before you may be rounded, by closing one eye and extending your arm, you can do two things: Flatten the curve of the top and bottom, and measure it.

Cheat Sheet

- *Seek the simplest expression of a shape in the form of straight or curved lines.*

- *Label or name the subject you are drawing in terms of its shape, not what you know it to be.*

- *Break up your subject into parts and practice drawing those parts before you tackle the entire thing.*

- *Ask yourself questions about what it is that you are actually seeing so that you truly understand what you're drawing.*

- *Measure a smaller shape in your drawing and compare it to other larger shapes to help keep your shapes in proportion.*

- *You can use any circular shape in your subject, similar to how you would use a line, to help you correctly place the other shapes.*

- *To better see the positive shapes of your subject, pay attention to the negative space around and between them.*

- *Turn a line drawing upside down to help you see shapes and spot problems more easily.*

- *When you can't get a particular shape right, compare a tracing of that shape from the reference photo to a tracing of your drawn attempt.*

- *Close one eye to flatten a three-dimensional object into two dimensions for measuring purposes and to check for angles and curves.*

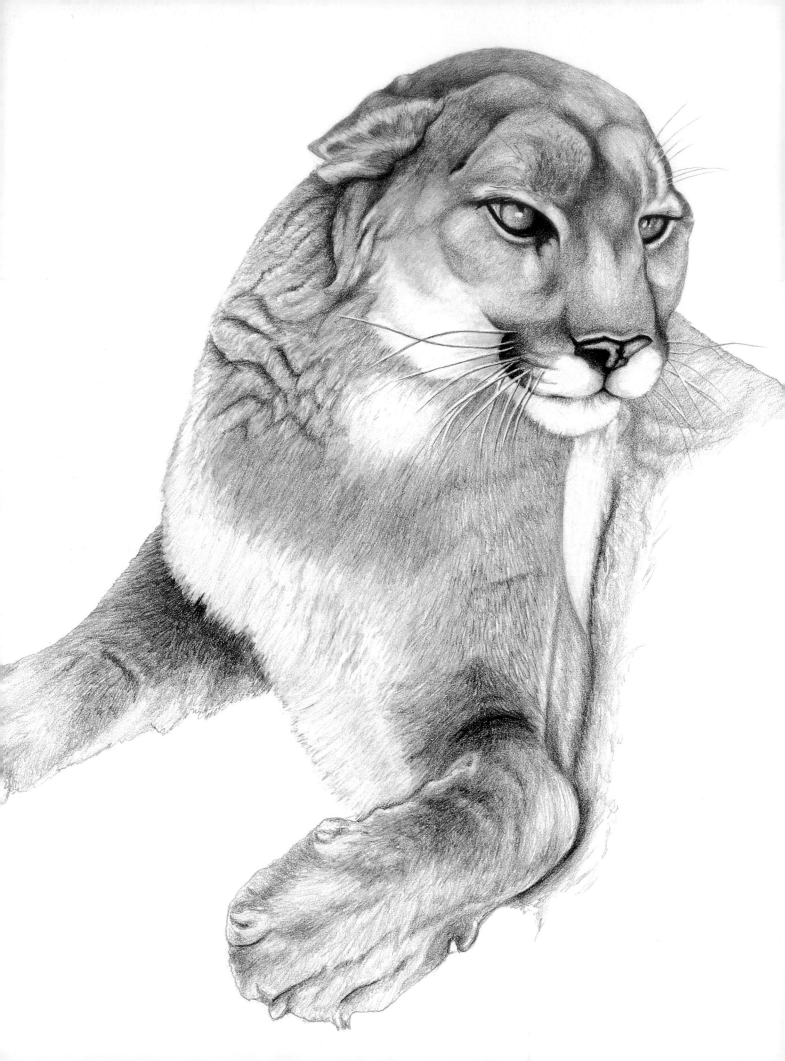

Shading

Shading With Pencil Strokes
This cougar was shaded with the pencil rather than smudged to create the different values. Whether you choose to smudge, hatch, crosshatch or build layers of graphite, your shading becomes like your handwriting—your own unique style and expression.

DAVE'S COUGAR
Graphite on bristol board
17" x 14" (43cm x 36cm)

I suspect that thus far in this book you have probably been more impressed with the shading in the finished works than the fact that they were drawn correctly. Shading is the icing on the cake; it's what brings your drawing to life. However, all the wonderful shading in the world won't help if the image is drawn inaccurately, assuming that your goal is realism. That's why shading comes after site and shape: It's the finished step that catapults your art from a single-dimension line drawing to a three-dimensional image. This chapter addresses and demonstrates how this is accomplished.

The process of getting the site and shapes right tends to be a bit mechanical, but may be accomplished fairly quickly with a few easy-to-grasp tools and techniques. Shading, however, is what typically separates the soon-to-be artist from the skilled pro. Why? Because shading takes practice. It takes an even pressure on the pencil, a smooth touch and an experienced eye. In chapter three we learned various pencilling, smudging and erasing techniques, all of which are used to shade. In this chapter we'll put those skills to practice.

Define With Values, Not Lines

In chapter two we learned how the mind places everything into patterns of perception, memorizes those patterns, then uses what's recorded in the mind rather than the reality of what's in front of us. Perceptions are more powerful than facts. And truth be told, most of the lines you draw are a perception, not a fact.

Say you are looking at a room painted white. How do you know there are walls and a ceiling? After all, they're all white. You might respond by pointing out that they have angles you can see. Look again. Why do you know there are

angles? Are there lines drawn on the walls and ceiling to tell you there are angles? What do you actually see?

To answer this question, first we need to understand what a line is. The most common definition of a line is "the shortest distance between two points." But that's not an artist's definition. A line, when used in a drawing, is a mark made on the paper to represent an edge of something—where one thing ends and something else begins. If I'm drawing my hand on a piece of paper, the lines I originally make represent the edges of my

hand and are used to separate my hand from the rest of the paper. The reality of my hand is that it is not outlined: There isn't a black mark that goes around the outside of my hand.

What our eyes see in reality are not distinct, sharp lines, but changes in value. The term *value* means the relative lightness or darkness of an area. It's the different shades of gray that range from the white of your paper to the darkest dark your pencil can make.

So, it is the changes in value, however subtle, that allow you to see where the

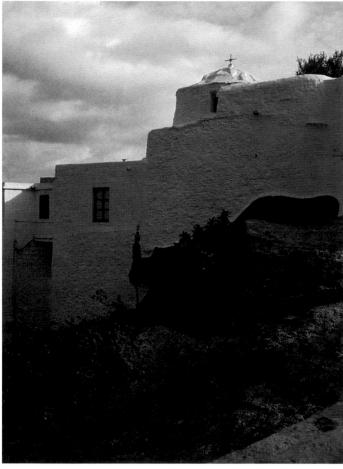

Reference Photo

Line Drawing
We initially draw the edges of the subject, placing them in the correct site and with the correct shapes.

walls end and the ceiling begins in the white room. One of your goals in shading is to make sure that you end up with value changes rather than lines defining your subject. There are very few real lines in this world, but there are countless value changes. Realistic drawings show value changes, not outlines.

Psssssst!

The closer in value two things are to each other, the less you can separate them with a line. In classic art training, you would practice your shading on a bunch of stuff painted white. This exercise forces you to practice subtle shading to define edges. It also simplifies things because you're not dealing with color.

Bad Shading

Now it comes time to shade. Those same lines, useful at first to indicate the edges of things, are not truly lines at all. But the emerging artist leaves them in place, and the drawing looks amateurish as a result.

Good Shading

Although both drawings are correctly drawn, this one is clearly drawn better. What's the difference? The lines left in the first drawing, where there are no lines in reality, change the work from professional to struggling artist. A much more realistic drawing is created when you use value changes rather than lines to define your subject. Don't leave lines!

How to Get Rid of Lines

Okay, so now you know that most of the lines in your drawing have to go in order for it to look realistic. How do you go about doing this? There are several ways to get rid of lines that were originally used to mark the edges in your drawing.

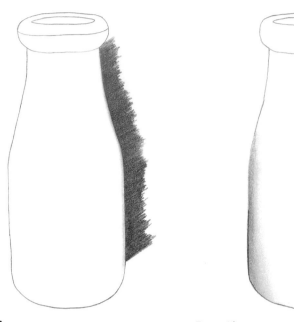

Absorb Lines
The background may be darkened so the line will be absorbed.

Erase Lines
The line may be erased so only the value change remains.

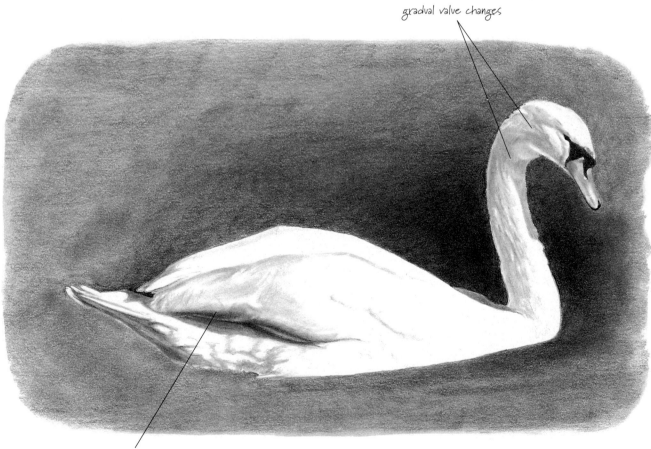

gradual value changes

gradual value changes

Blend Lines
The line may be blended into the image where there's a gradual value change.

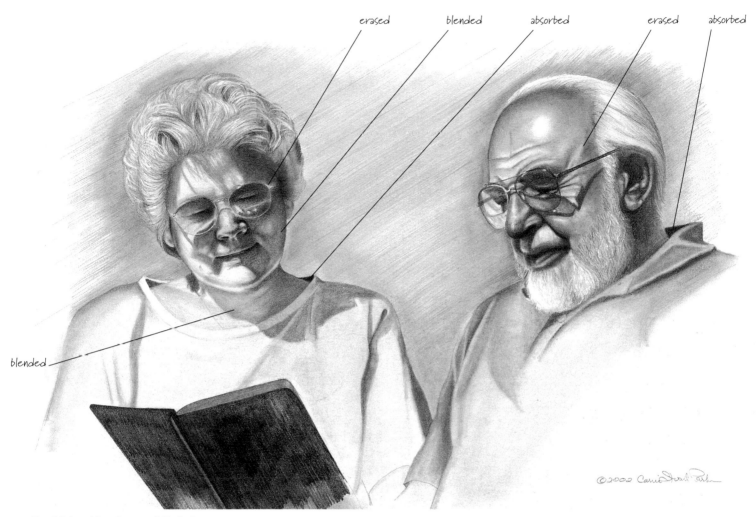

erased blended absorbed erased absorbed

blended

blended

©2002 Carrie Stuart Parks

Combining Line Removal Techniques

Most drawings will require you to use a variety of techniques to eliminate lines: absorbing some, erasing others and blending some into the shadows.

PASTOR AND EDNA DAY
Graphite on bristol board
14" x 17" (36cm x 43cm)

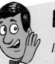

Pssssst!

In your drawings, examine areas that were originally drawn as lines. When deciding which lines will stay and which will go, look at each line and ask yourself if it really appears as a line in the reference photo or live reference, or if it is a value change.

Isolate and Squint to See Values

The answer to the age-old question "How do you eat an elephant?" is this: One bite at a time. How do you shade a complicated subject? One little part at a time. Isolate the individual parts of your drawing and see them as shapes with different values.

In spite of the parental admonition that squinting may cause your face to remain in that pose, squinting in art is a rather useful tool. When you squint, edges blur and you are left with lights and darks. Artists know this and often squint at the subjects they are drawing to more clearly see value changes.

Although I'm encouraging you to isolate specific areas and concentrate on the value changes, you'll need to be sure you look at the entire drawing and adjust accordingly. Make it a habit to shade a single area, walk away, then return and check that the value is correct to the overall image.

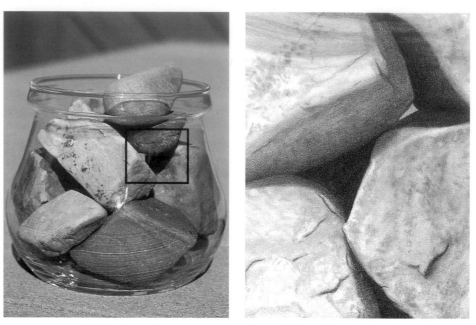

Break Down the Complex
It turns out that there wasn't just one lesson in that jar back on page 52. That image has a very complicated series of shadows and lights, so the drawing was broken up into smaller sections. The different parts, such as the section shown here, were isolated and viewed as shapes: square light shapes, rectangular midtones and rounded darks. The shades (values) are nothing more than shapes. Don't try to analyze why something is round or square, dark or light. Just duplicate what you see.

Pssssst!

Although not technically the same as the classic "squint," another tool for seeing value changes is a piece of red acetate. Colors have a way of interfering with our ability to distinguish values. Hold the acetate in front of your face or place it over the reference photo and it renders your subject into only values, removing the distraction of color.

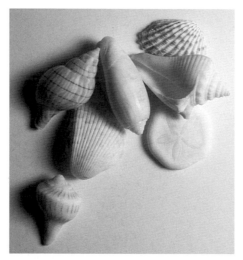

Squint to See Values Easier
Squinting at these shells encourages our eyes to focus on seeing values, not details.

Compare Values and Avoid the Guessing Game

It is always easier to make relative judgments rather than absolute judgments when it comes to art. Something is "too big" or "too small," "too light" or "too dark," in reference to something else.

A value scale is an invaluable aid for comparing values as you shade. You can buy a value scale or easily make one yourself with a piece of bristol board and a pencil. A value scale contains ten blocks of values ranging from black to white, with tones of gray in between. A hole is usually punched in each block. Place the scale over the different areas of the reference photo you are using to determine the correct amount of shading needed to duplicate what you are drawing.

Don't Guess at What You Can't See

One very important question to ask yourself when drawing is: Why do I see that? Force yourself to answer. You actually see something because there is a value change. Something is either lighter or darker than something else. When you ask this question, you are forcing yourself to analyze rather than guess at the values.

This question becomes especially important when you can't see everything in the reference photo, such as when details are lost in the dark areas. Many artists think they need to fill in the missing details. Guesswork like this can lead to drawing disaster. If you don't see it,

don't guess. Don't try to figure out what's happening in that mysterious dark area, because you'll be running it through your perceptions of reality instead of seeing it for what it is.

Value Scale
This is a handy tool for working out the value problems in a drawing.

Guessing at Reality
This is what commonly happens when an artist tries to fill in the blanks of what they can't see in a reference photo. Scary!

Leave a Little Mystery
So what if we can't see every single detail of the dog's face? The drawing is better for it.

Punch Up the Contrast

I have come across many competent art students who are able to render beautifully drawn art, but their drawings aren't particularly interesting. It's because they lack contrast. Usually the drawings are very light in appearance with no true darks. An interesting drawing ranges through the full value scale, from white to black, with tones in between.

Let's take the following washed-out drawing from so-so to spectacular by heightening the contrast and adjusting its values.

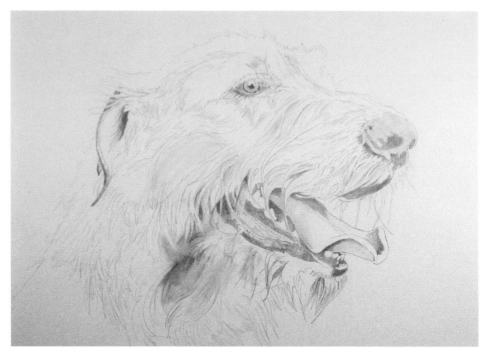

A Drawing With No Draw
This is a nice but boring drawing. The values were created with a very timid hand. The shapes are dead-on and everything's well proportioned, but will the viewer even notice?

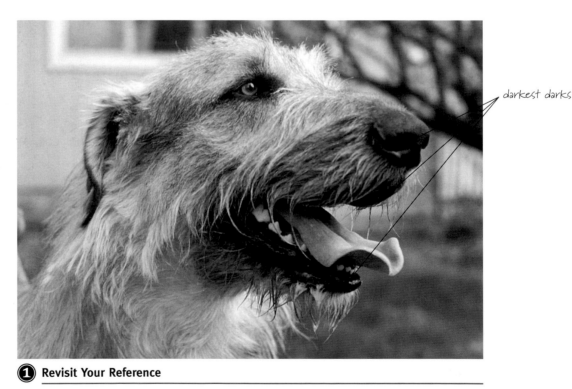

darkest darks

1 Revisit Your Reference

The drawing needs more contrast, but where do we begin? Go back to the photo and find a place on the subject that's dark—really dark. The dog's nostrils and lips look like the best bet.

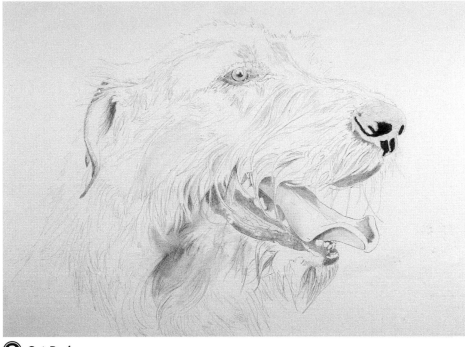

② Get Dark

Now take a 6B pencil and begin darkening those spots on your drawing. Push hard. Harder. There, now you can take a deep breath. That was the hardest part.

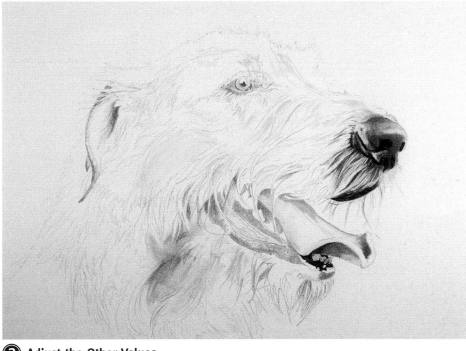

③ Adjust the Other Values

In order to fix this drawing, you now have to adjust the remaining values so the darkest value you just created no longer awkwardly jumps out of your drawing. Start small with the hair at the tip of the nose and the tongue.

Pssssst!

If your drawing looks pale, place a single black mark on the paper. This forces you to adjust the values, making the rest of the drawing darker and therefore more interesting.

④ Keep Going

Progress to the dog's eye and the corner of his mouth, adjusting values as you go. Notice the variety of techniques used: close pencil strokes for darker areas on the fur and spaced-out strokes for the lighter areas; smudging for midtones; and erasing (or lifting graphite) for highlights on the nose, eye and tongue. Using an eraser to lift very small groupings of hair strands not only adds depth to the values of the drawing but also creates the realistic texture of fur.

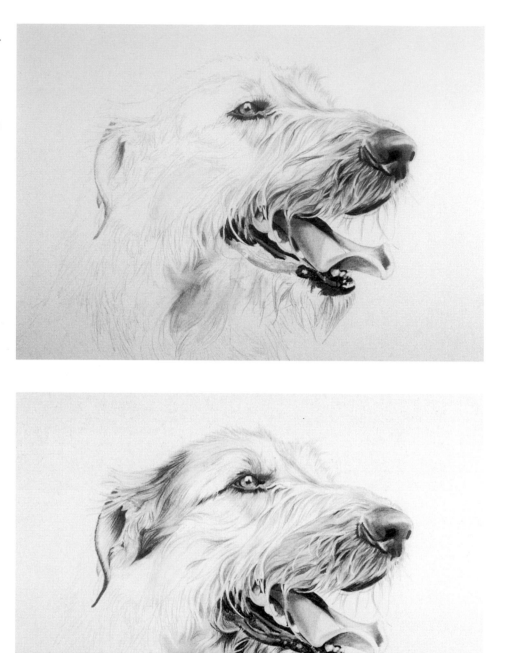

⑤ And Going ...

Work your way back to the dog's ear. Just remember not to darken everything—the dark values will only be effective if they appear next to lighter ones.

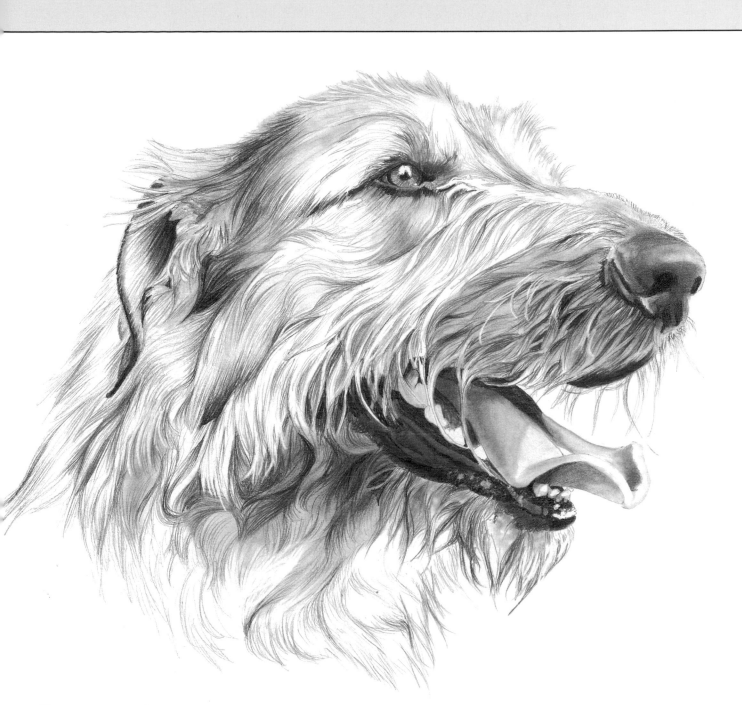

⑥ ... There! Much Better

The reworked drawing has much more depth, realism and interest than the original. Well-executed values and enough contrast can make all the difference between a ho-hum drawing and an eye-catching work of art.

IRISH WOLFHOUND
Graphite on bristol board
14" x 17" (36cm x 43cm)

Seek to Understand the Effects of Light

Regardless of your choice of shading technique, you need to learn how to spot the different characteristics of light and shadow on your subject and recognize the potential challenges of recreating them on your paper. The effects of the light source are different depending on whether your subject is round or angular.

Working in the Round

I received a call a number of years ago from a friend in Long Island about an upcoming portrait drawing class. In a thick New York accent, he informed me that he was going to start the class by having everyone "drarl a bull."

This was a new one for me, so I asked why he would want to teach a class to "drarl a bull." He replied, "Because the face is based on a bull." Now, I was raised on a ranch, and I know a bit about bulls and cows in general. I had never observed the similarity between a human face and a bull. I thought that maybe the breed of bull made a difference—I mean, an Angus looks different from a Scottish Highlander bull—so I politely asked about the breed. There was an astonished silence; then in a quiet voice, he said, "A bull, a round bull. What was I supposed to call it, a sphere?"

So, let's talk about bulls—I mean balls. Round stuff. Most drawing classes require you to shade a ball and often other round things like cylinders and cones. Why this obsession with round? Because there's a pattern of darks and lights that occurs on something round and because it is affected by a light source. If you can shade using this pattern, you will create the appearance of something round and capture the three-dimensional feel of the subject.

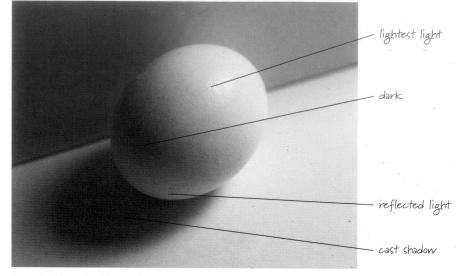

lightest light

dark

reflected light

cast shadow

Round objects have a predictable pattern of lightest light, dark, reflected light and cast shadow that helps to define their shape.

Angular subjects like this cube will show more abrupt value changes than what you see on rounded objects.

Psssssst!

Objects lit by natural light will have a predictable shadow because light rays travel in parallel lines, whereas artificial light may come from more than one source and cause more than one shadow.

The pattern of lightest light, dark, reflected light and cast shadow may be placed on any subject and it will create the appearance of roundness. Now, I realize I just said, "If you don't see it, don't draw it." This is the exception that proves the rule … or something like that.

Angular Subjects

Unlike round objects that shade gradually from the highlighted area through midtone grays into the dark shadows, angular subjects have abrupt edges and relatively little value changes within the flat surface. There may be reflected light on an angular surface—for example, a flowerpot sitting on a porch may cast a glow onto the wall behind it—so we want to be on the lookout for interesting plays of lights and darks. The technique of squinting will serve you well when observing more angular surfaces.

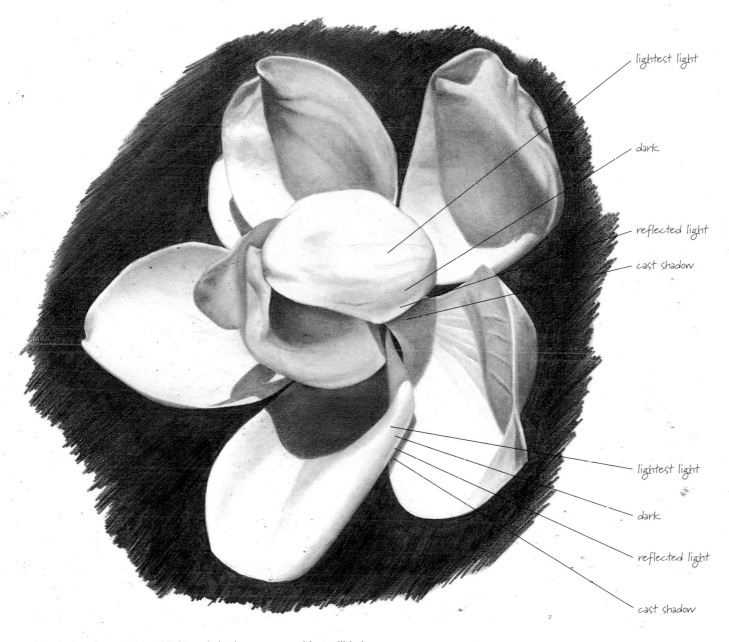

lightest light

dark

reflected light

cast shadow

lightest light

dark

reflected light

cast shadow

Developing the patterns of light and shadow on any subject will help realistically define its form.

Check for Accuracy

You've spent quality time with your pencils, established a working relationship with your eraser and finally (FINALLY) completed your drawing. Congratulations! Now, there is still a chance, albeit remote, that your art might not look quite right. Let's talk about checking for accuracy.

In the beginning of the book, I introduced the concept of patterns of perception. The mind organizes the items we want to draw into patterns, memorizes those patterns and trots them out when we draw. It is these often limited perceptions that keep us from drawing well.

We need to learn a few techniques to break up these patterns and refresh our minds. This will make it easier to determine what is incorrect in our drawings. Most of these techniques have been around for awhile, and many artists use them without thinking about it too much. To make your drawings better, routinely add some of the following techniques to your drawing process.

Invert for a New Perspective

Inversion, as we learned earlier, means to turn something upside down. At some point in the drawing process, turn your artwork upside down to gain a new perspective on it. If you are working from a reference photo, invert it as well and place it beside your drawing. You may spot errors or problems more clearly.

Get Some Distance

Chances are you've hovered over your drawing from a fixed distance as you've worked on it. Now you need to change the distance. Get up and view your drawing from further away. Post it on a wall. Changing the distance will make the value problems more pronounced and will give you better insight into any potential problems.

Take a Break

Shortly after you began your drawing, your mind processed it and committed it to memory. You need a break from your art and the image you are drawing. Go get a cup of tea, check the weather or call your mom. Physically get away from your work, then return and study it. You will have a small window of time to see the errors before your mind reprocesses the work. Have a pad of paper with you and immediately record the errors. Otherwise, you'll forget.

Use Your New Tools

In this book I've described a variety of tools to help you draw well. These tools can help you see your artwork better. Take a ruler to your drawing and make sure things are where they should be. Look at your drawing through a piece of red acetate to check your values (or just squint). Put your tools to good use, and they will serve you well.

Shift Into Reverse

Hold your drawing up to a mirror and look at the image in reverse. Like inversion, this time-tested technique changes the look of the art and may help you spot (and fix) previously unseen problems.

Ask Friends and Family

Assuming you have members of your family or friends that will be helpful without reducing you to shark chum, you might want to ask them what they think of your drawing. They may not be artists themselves, but they are your viewers, and they can give you a different perspective you might want to consider. They may wonder what the black blob at the bottom of the sketch represents—the blob that you thought was an artsy touch.

Once I asked my mom about a portrait I had completed. I thought it was really creative. She wanted to know why I made the nose blue. That's all she saw: that blue nose. As my purpose was not to create an artistic statement on blue noses, I decided to change the piece.

Approach Other Artists

Fellow artists can help critique your drawings, too. Some artists and budding artists are members of art groups, but not every art group critiques each other's work. If you're not a member of a group that reviews each other's art, try visiting a teacher at the local art center or asking a friendly artist-type neighbor for an informal critique.

Try a Combination

The best way to check your art for accuracy is with a combination of several of these techniques. I walk away from my work, wait a bit, come back, make notes, ask my husband and look at it upside down. Find a set of techniques comfortable for you and try it.

Make Accuracy Checks a Part of Your Routine

This composite sketch was completed by a student from one of my drawing courses. Even though a facial composite drawing is an image made from putting together the features of different faces, each element must be checked for accuracy against the features in the individual reference photos selected by the witness. Sheila is an outstanding artist, partly because she is always on the lookout for possible errors occurring within the drawing. For artists like Sheila, accuracy-checking tools such as reassessing a drawing after taking a break from it, or viewing it from a distance, are a matter of course.

PRETTY BOY
Sergeant Sheila Tajima-Shadle, Fremont Police Department, California
Graphite on bristol board
10" x 8" (25cm x 20cm)

Cheat Sheet

- The lines in a line drawing are meant to represent the edges of things. Leaving these outlines in your finished drawing will make it look amateurish and unrealistic.
- Use changes in value—that is, the lights and darks—to ultimately define your subject, not lines.
- You can get rid of lines by absorbing them into a darker background, erasing them and leaving only a value change, or blending them into a value change.
- Simplify complex subjects by isolating parts of the drawing and seeing them as shapes with different values.
- Squint at your subject to see the value changes more clearly.
- Use a value scale to help you build a range of values in your drawing.
- Draw what you see; don't guess. Leave an area undetailed if that's how a part of your reference photo looks.
- If your drawing looks boring, add more darks and adjust the values accordingly for more contrast.
- Pay attention to how the light source affects round and angular subjects.
- Your drawings will be better if you use a number of accuracy-checking techniques.

Drawing Practice

Drawing White on White
One of the biggest challenges of this piece was drawing and shading a white mug on a white background. Some of the original lines were left to define the shape and texture of the subject.

STILL LIFE WITH ANTIQUE WOOD PLANER
Graphite on bristol board
14" x 17" (36cm x 43cm)

If you want to produce realistic drawings such as the ones you see in this book, you will need to practice. And practice. And practice some more. The demonstrations in this chapter will help you do that. Please, however, don't think that loosely sketched drawings, drawings with exaggerated features or studies in lights and darks are in any way wrong, unacceptable or anything less than wonderful in their own right. You'll need to do many drawings in many styles and under various circumstances to improve as an artist. You're on a journey with lots of side trips.

Rendering Hair on a Mountain Goat

This fellow was lying in the dappled shade along the path at the top of Logan Pass at Glacier National Park in Montana. We will use a number of different pencilling, blending and erasing techniques to not only accurately draw the goat, but also to render the light effects on its body.

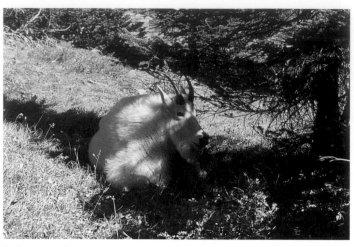

Reference Photo

Pssssst!

Before you can begin to shade your drawing, erase all the guidelines, marks, aids and notes that you used to get the image right. I know, it sounds like a reminder of the obvious, but it's easy to forget and almost impossible to remove them once the shading process has begun.

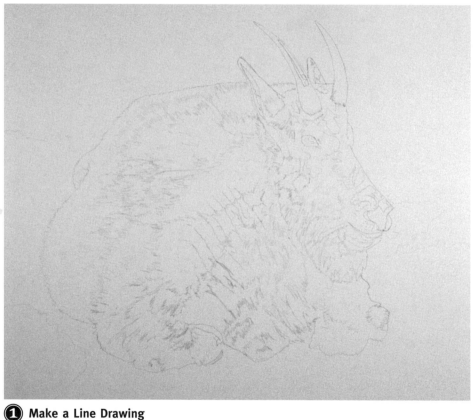

❶ Make a Line Drawing

Make a line drawing from the photo, or copy this one. This drawing was rendered extremely light and may be hard to see. You'll want to keep your drawing as light as possible at first. Erase any guidelines that you use.

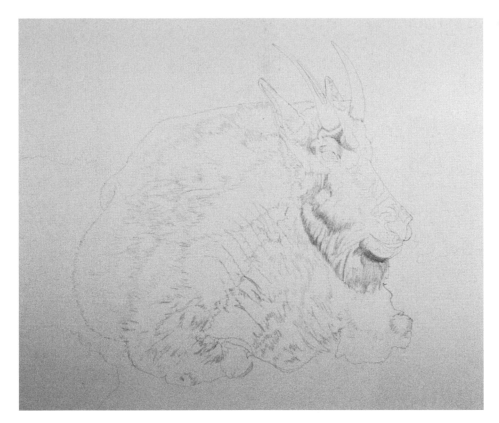

② Add Some Midtones

There's no rule that says a particular area of your subject needs to be drawn first. Just select a midtone and jump right in. There is a secret, though, to drawing fur: "Comb" the fur with your pencil. That is, your pencil strokes should go in the same direction as the fur or hair.

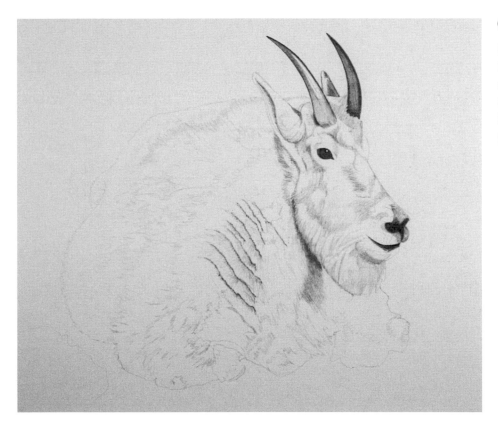

③ Add Darks

Pencil in those darks so the range of values is in front of you. A 6B pencil is a good choice for this. Don't be shy—remember when we looked at drawings that weren't interesting because the value range wasn't present?

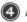

④ Adjust Values and Continue to Darken

Now that the darks are in place, we can adjust and reshade to correct the values.

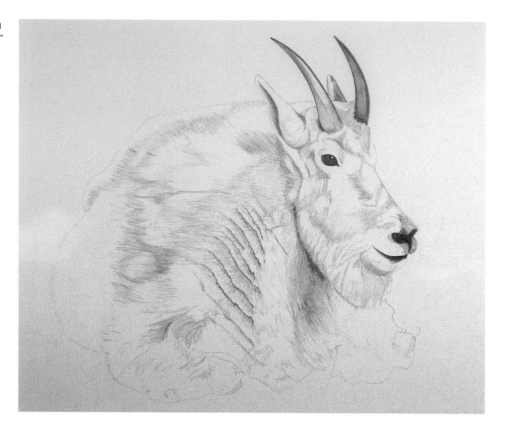

⑤ Blend

With a paper stump, blend your strokes together to create the shadows. This will lighten the drawing and you'll lose some of the fur-like look. Don't worry, though; we'll come back and fix it.

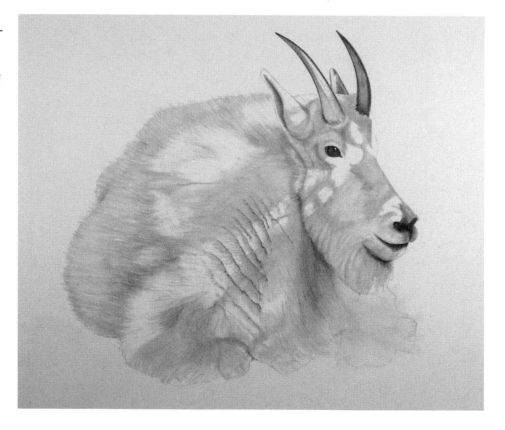

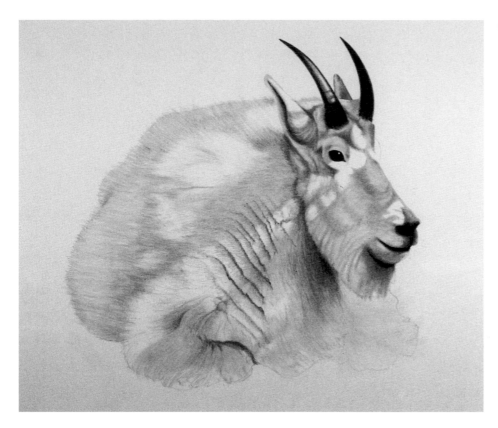

⑥ Comb the Fur Again

Take an HB or 2B (very sharp) pencil and recomb the fur to provide the correct texture and reestablish the direction of the hair. Darken the areas that got lighter when you smudged.

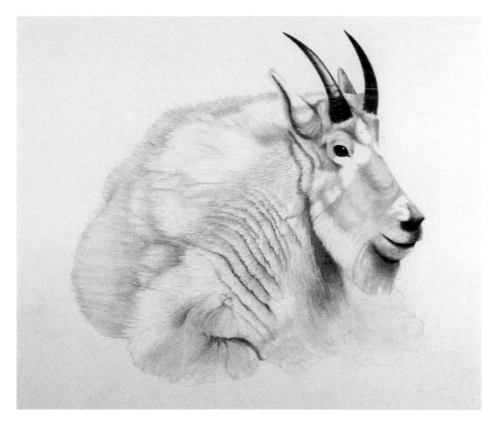

⑦ Erase

Erase the dappled sunlight back out. If you are using an electric eraser, place it on a somewhat rough surface, turn it on and create a point in your eraser. Use it like a pencil and comb white hairs in the fur. You'll lose the point as you go on, so you'll need to repoint the tip as you erase. If you're using a white plastic eraser, simply take a craft knife and whittle a sharp edge to do this.

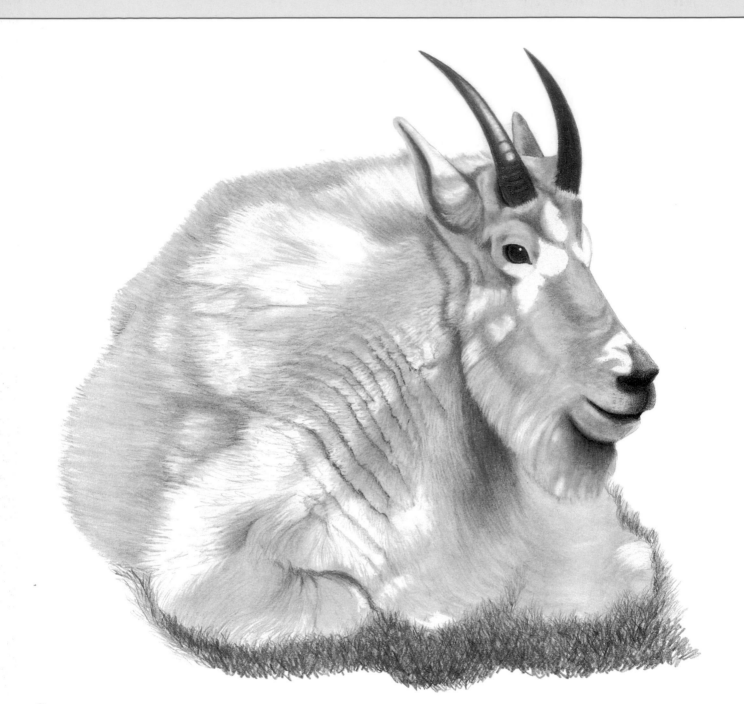

⑧ Adjust

The eraser is not hair-fine, so go back to those erased "fat" hairs and use your pencil to thin the hairs and break up the whites. Soften the highlights and adjust the values yet again. Ground the goat using a soft graphite pencil in short strokes to add grass.

GLACIER MOUNTAIN GOAT
Graphite on bristol board
14" x 17" (36cm x 43cm)

Drawing a Detailed Sword Handle

This is an 1864 light calvary saber with several unique drawing challenges. The man-made shapes need to be rendered with some type of mechanical assistance if the finished drawing is to be realistic. That's not to say it can't be drawn free-hand and kept more sketchy, but if you choose to make it as real as possible, French curves and rulers are recommended. The different metallic surfaces, some shiny and some matte finished, are also a challenge and require different pencil strokes.

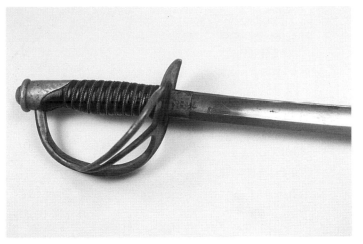

Reference Photo

① Make a Line Drawing

The sword was drawn freehand and the guidelines erased. Copy this drawing. Remember to not push too hard if you're using a harder lead, as those lines will score or gouge your paper. Some of the areas that will later be shaded are outlined or marked.

② Mechanically Clean Up the Drawing

We learned earlier in the book about the use of mechanical aids. This is a drawing of a mechanical, manmade object, so the use of French curves renders a more precise drawing. Go back over the initial handle and make it more mechanically perfect. Use an HB pencil to darken the links.

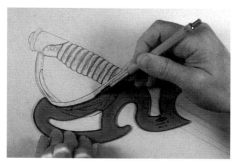

Detail
The French curve allows for greater control and smoother lines when you're drawing the curved handle.

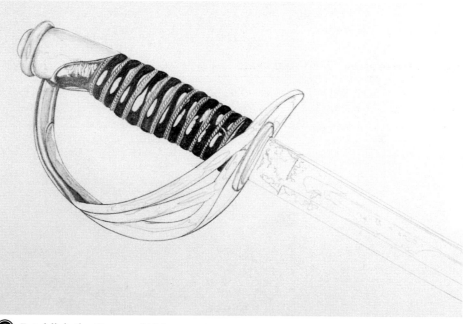

③ Establish the Range of Values

In this first shading, establish the darkest areas, some midtones and the lights. This provides the full range of tones that will be present in the finished drawing. The darkness in the handle should be shaded away from the highlights and to the outlined edge. Darken the details of the chain-like shapes.

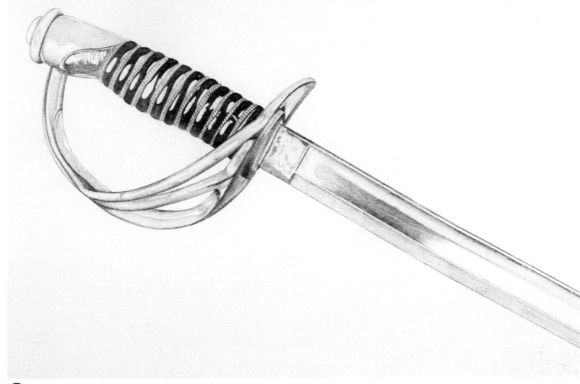

④ Adjust Values and Eliminate Outlines

Using the pencil only—no smudging at this point—adjust the tones of gray (the values) over the entire sword. The goal at this point is to eliminate the lines originally used to sketch the outline of the sword by absorbing them into the various values.

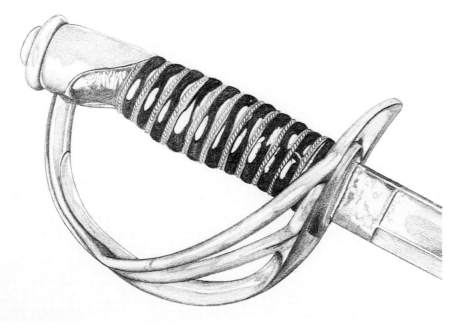

Detail
Notice that the pencil strokes are smooth, even in tone and very close together.

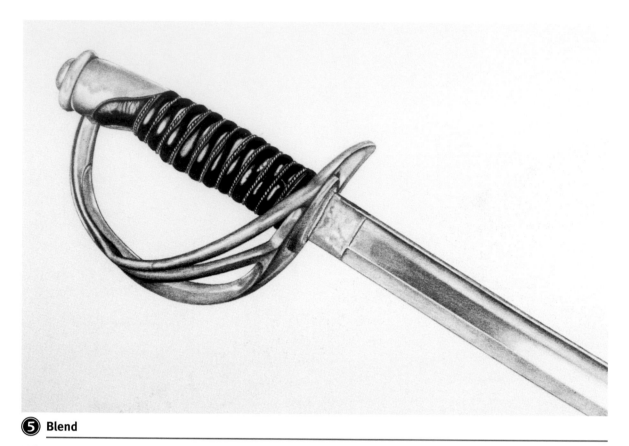

⑤ Blend

Using a paper stump, blend the strokes together and smudge the highlights.

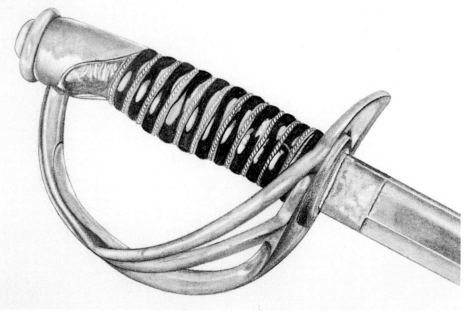

Detail
Now the handle begins to look truly realistic.

⑥ Erase Highlights

Using an electric eraser, restore the highlights to white. Use a kneaded rubber eraser to add texture by pushing it straight down, then lifting straight up.

SWORD
Graphite on bristol board
14" x 17" (36cm x 43cm)

Building the Values of a Water Lily

Our dear friends Dave and Andrea Kramer have their own personal lake complete with a picturesque corner of water lillies. I've painted them many times in watercolor, but never drawn them in pencil. There were several challenges in this subject, including the numerous values of gray and rendering the petals so they appear to be underwater. I started the drawing without first creating a black and white version. That was a bad idea. I originally shaded based on color changes, not value changes.

Reference Photo

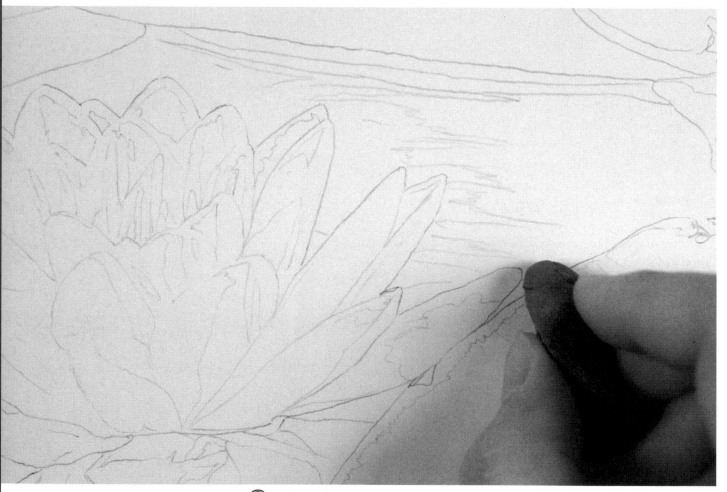

① Make a Line Drawing

Make a line drawing based on the photo. If you use guidelines or a complete grid, erase them completely before moving on to the shading.

② Place a Midtone

Find a middle value in the photo and shade that area of your drawing. Check it by using a value scale.

③ Establish a Range

Now find a good dark area and a good light area and establish the range of values that will appear in your drawing. The variations in values may be rather subtle in some places as you develop the rest of the drawing, so check to see that everything isn't ending up looking the same. Keep returning to areas and adding the darks so your eye always has a range of darks in front of it.

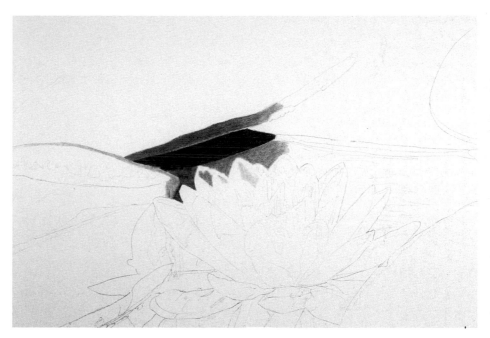

(4) Think Shapes, Not Stuff

Earlier in the book we talked about how the mind can form a filter and prevent us from drawing well. At this stage in the drawing when you're developing the shading, it's important not to fall into thinking, "Ah, that's a petal! And that's a leaf!" Instead, think, "That's a square of mid-gray under that white thing, with a black line on the one edge." I even put my finger on the spot so I don't lose my place. If it is drawn correctly, the shading will resolve itself.

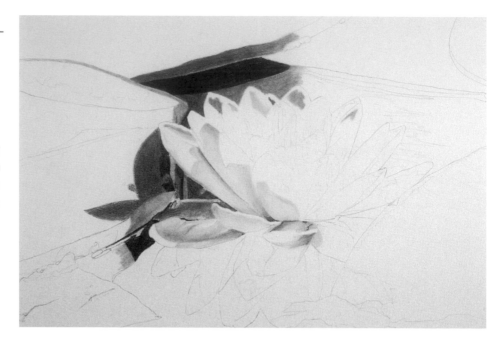

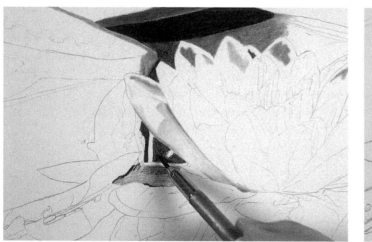

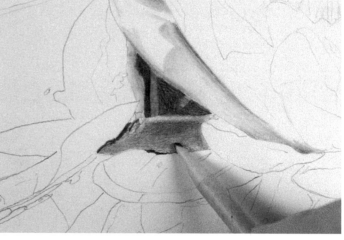

Details

I originally left a white area between two shaded areas. When I blended the two midtone values on either side, I just ran the blending tool over the white and it formed the proper value with just the graphite on the blending tool.

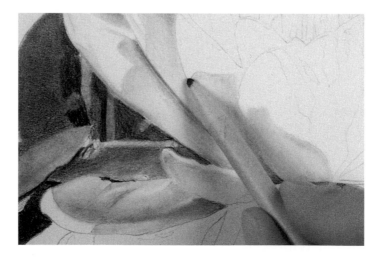

Detail

Every time you add graphite, you make something darker and a bit rougher. If you blend after adding the pencil, you smooth and lighten. You may go back and forth between shading with your pencil and blending with your paper stump many times.

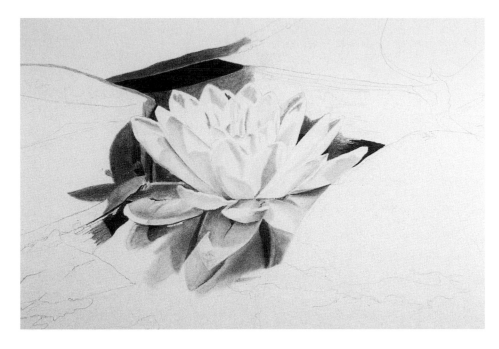

⑤ Work Over the Whole

As you continue to shade and adjust and the flower starts to emerge, look more at the overall picture and less at the little puzzle pieces.

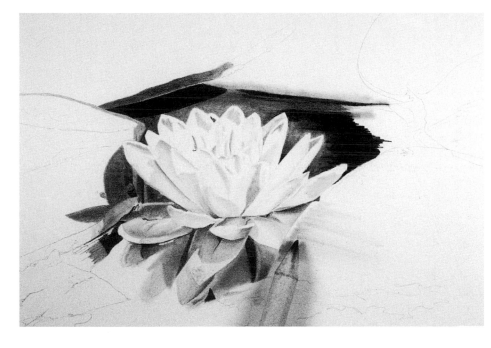

⑥ Place Big Darks Carefully

I usually don't put in a really big dark until I'm well into the drawing, because I might smudge it on the rest of the work. Proceed with caution!

⑦ Keep Going

Keep building values all over the drawing. Do the leaf shading by using the random built-up graphite on the paper stump and drawing it across the leaf in the direction the shading is indicated.

Take some breaks and check your work after the break. It may look fine when you leave, but you may notice it needs adjustment when you return.

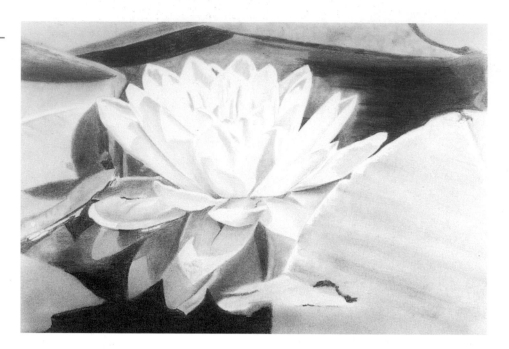

⑧ Darken, Adjust and Clarify

See? The drawing needed to be darkened some more and the shading smoothed again. The leaf on the left of the flower is further defined with values. Use a sharpened electric eraser to clean up the slivers of white highlight on the flower.

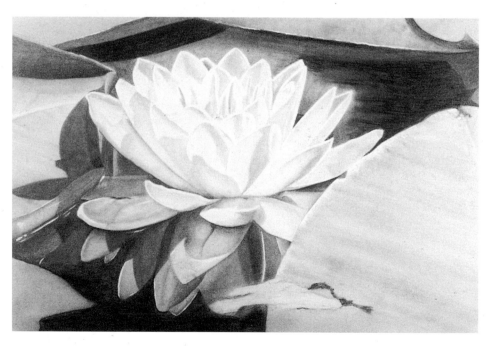

Detail

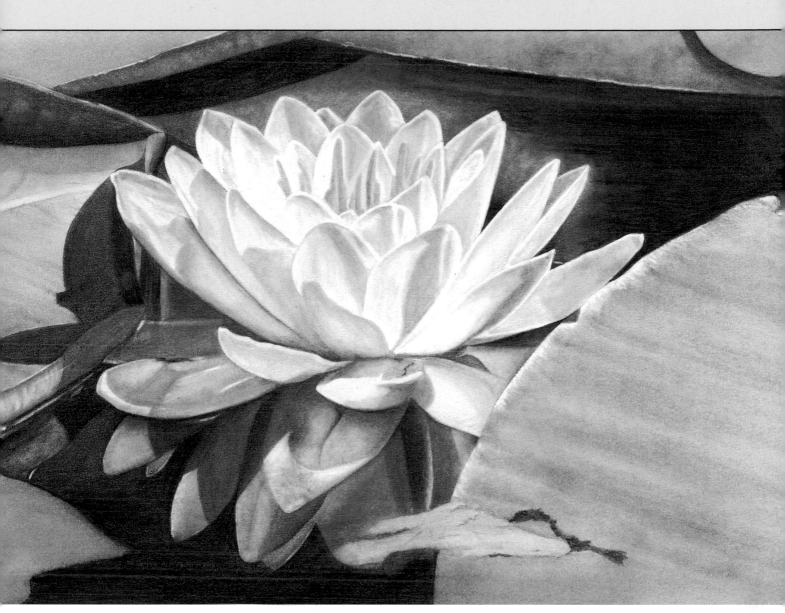

DAVE AND ANDREA'S POND (WATER LILY)
Graphite on bristol board 14" x 17" (36xcm x 43cm)

Psssssst!

This isn't a book on design, but design is part of art. Design and composition are often used interchangeably. It refers to the way the objects on the work of art are handled: Line, color, space, texture, value and a host of other factors join together to add to the design of a work of art. In a book as basic as this, our goal is to make the drawing look interesting and deliberate, not like an accident.

Here are a few suggestions to help you:

- *Try to keep your drawing from having a single object in the center (the bull's-eye look).*

- *Think about connecting your drawing to the edges of the paper, but don't look like you ran out of paper.*
- *Divide the objects or elements of your subject into groupings that provide variety.*
- *Pay attention to what you see first when you look at the drawing. Do your eyes bounce back and forth between two equal (and therefore competing) objects, or do they flow from one object to the next?*
- *When in doubt, cut the paper to better frame the drawing.*

Capturing the Values in a Skull

We've talked about becoming a shutter-bug and taking pictures of everything around you for possible artwork. This skull was part of the decorations in the rustic lodge at Busterback Ranch in the Stanley Basin in Idaho. This photograph was taken more than fifteen years ago. Subtle as well as dramatic shading will be required to render it in pencil.

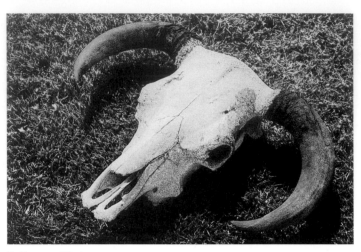

Reference Photo

① Make a Line Drawing and Begin Light Shading

Make a line drawing from the photo and compare it to the line drawing shown. Don't forget to erase any guidelines you use. This particular subject has many complex areas of lights, midtones and darks. Rather than sketch the edges or outlines of where the different values come together, we look at these areas as shapes and lightly shade them in. Otherwise we'd have to mark them or somehow note to ourselves, "Ah, this little area shaped like Florida is a midtone."

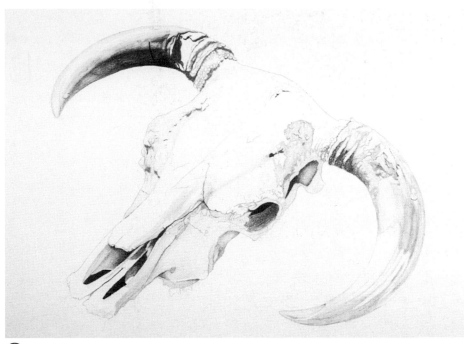

② Establish Some Darks

Find a dark area and really darken it with your pencil so the full range of darkest darks to lightest lights is now in front of you. With a 2B to 6B pencil, go over the entire sketch and reassess the values, adjusting them so the range of lights to darks more closely matches the photo.

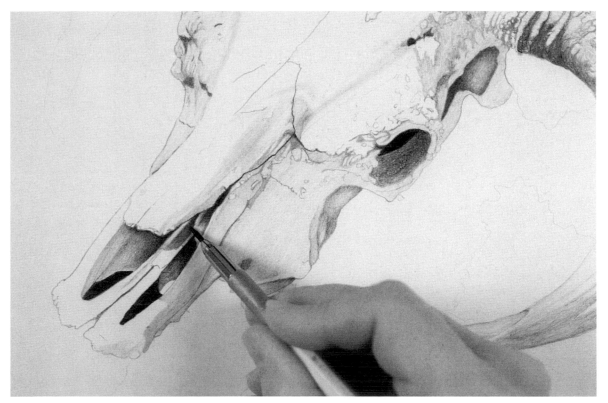

Detail

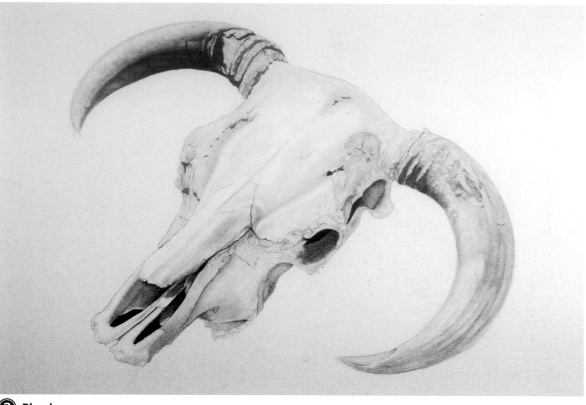

❸ Blend

Using the side of your paper stump, blend the pencil strokes together for a smooth appearance. This will lighten the dark areas of the drawing somewhat as you are lifting the graphite, but don't worry about it; we'll go back and re-adjust later. Work your stump evenly over the areas that will be considered white in the finished drawing, adding a light tone to these areas.

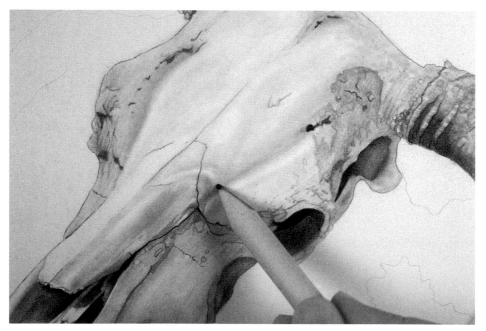

Detail

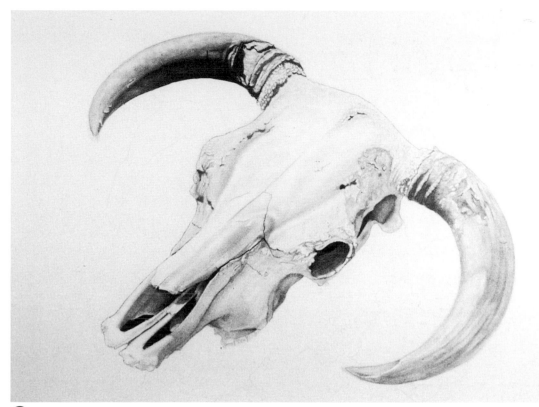

④ Erase Out Your Whites

Go back to the areas that were originally white and blended to a light value in step three. With a sharpened electric eraser, or a white plastic eraser with a sharp edge, erase out the white areas.

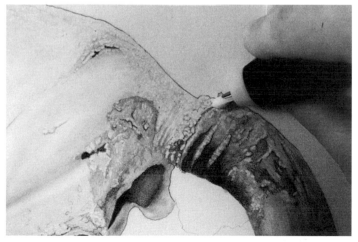

Detail
An electric eraser is incredibly useful for erasing out the most intricate whites, which will result in true-to-life texture.

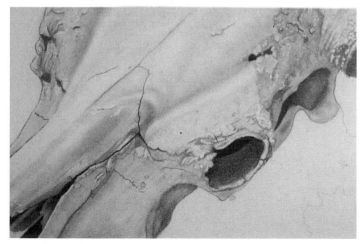

Detail
The whites were established around the eye sockets, among other areas.

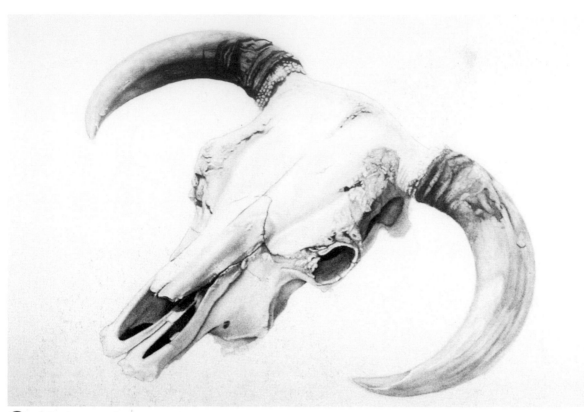

⑤ Re-Darken

Using a 6B pencil, go back to the areas that were originally your darkest darks and re-darken them, emphasizing the lighter areas. This is where you can fuss your little heart out over the itty-bitty details.

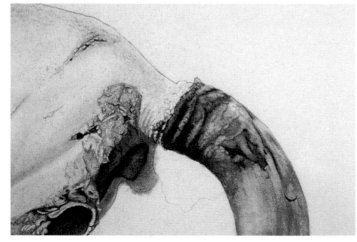

Detail

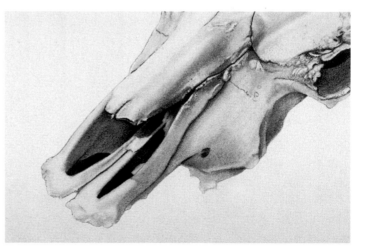

Detail

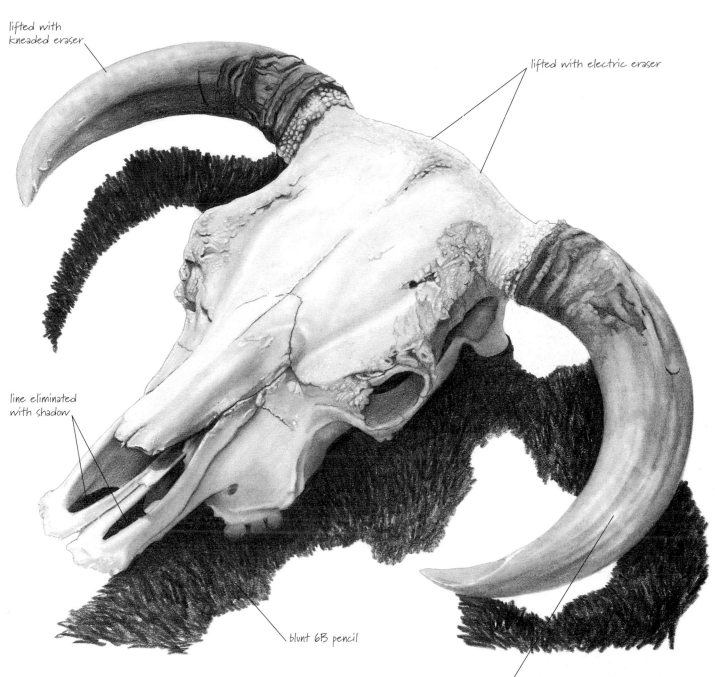

lifted with
kneaded eraser

lifted with electric eraser

line eliminated
with shadow

blunt 6B pencil

streaked with
kneaded eraser

⑥ Finish

The lines that originally went around the skull have now been
eliminated by the shadow or erased. A few more areas were erased
and texture placed by lifting those areas with a kneaded eraser.

SKULL—STANLEY BASIN, IDAHO
Graphite on bristol board
14" x 17" (36cm x 43cm)

Fine-Tuning the Shading on a Greek Torso

This drawing is from a photo we took of one of the Greek sculptures at the Parthenon. I did the initial shading, then turned it over to Rick to fine-tune it. He worked on just one side, the right, so the difference would be abundantly clear. This demonstration shows just how realistic you can make your drawings if you take the time to refine the details.

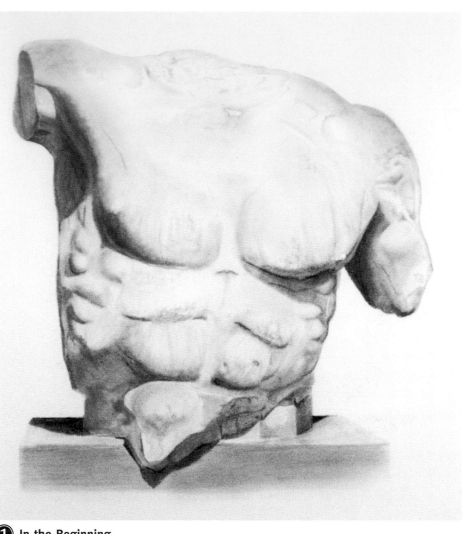

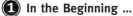 **In the Beginning ...**

This was the original drawing I gave to Rick. I thought it looked pretty good. Watch Rick work his magic with the pencil, stump and eraser to make it even better.

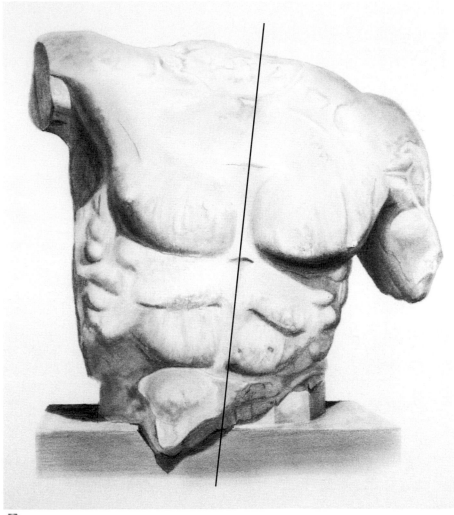

② Darken With Pencil

The first thing Rick did was to go over the right half of the drawing with a pencil, darkening my shadows but keeping the textures in place.

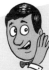

Pssssst!

It doesn't matter what technique you choose to use for shading. The technique, whether it's hatching, crosshatching, smudging or a combination, is a matter of personal taste, skill and the statement you want to make with your drawing.

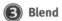 **Blend**

He now blends his strokes together, smoothing out some areas where the stone is smooth and using short, random strokes to create the rougher parts of the stone.

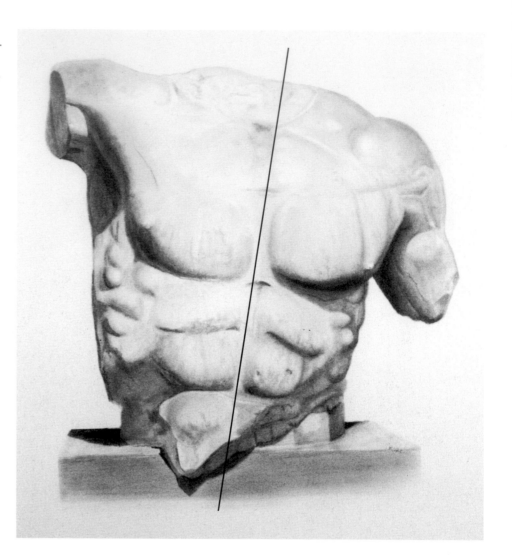

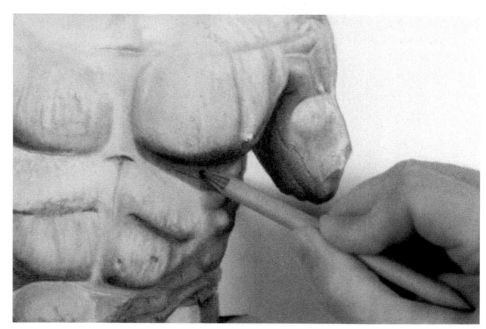

Detail

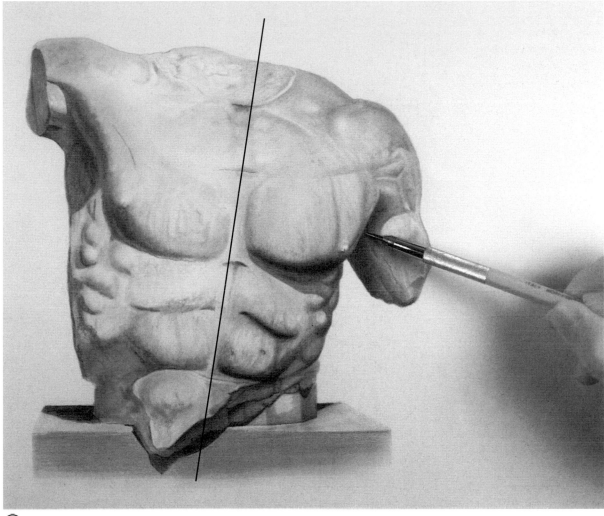

4 Back to the Pencil

The blending step will take some of the more linear texture out of the drawing, so the pencil is again used to reestablish the cracks and smaller roughened areas.

5 Lift Texture

Using a kneaded rubber eraser, some of the uniform dark areas are lifted. This creates the naturally uneven look of stone.

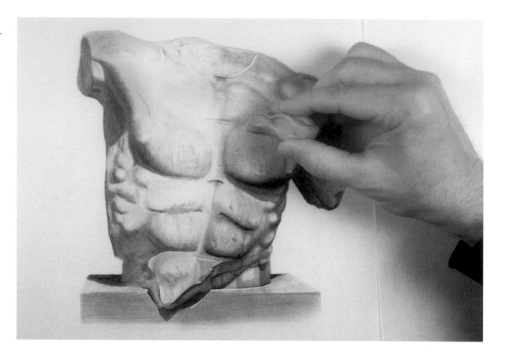

6 Erase

Fine white areas are erased with the electric eraser, which has been sharpened to a point. If you lift too large an area, you can come back in with a pencil. Remember, you also learned how to create a template if you need to make a very fine line.

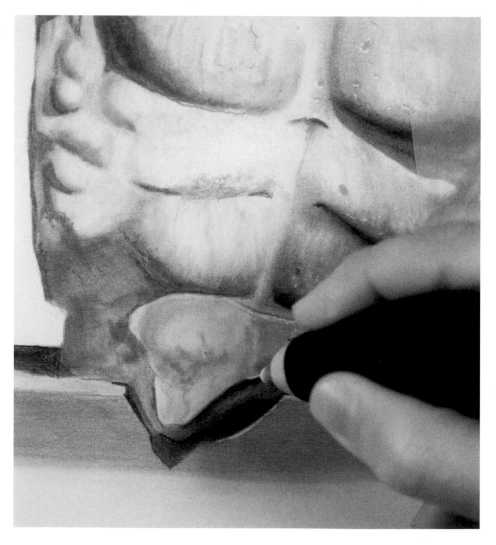

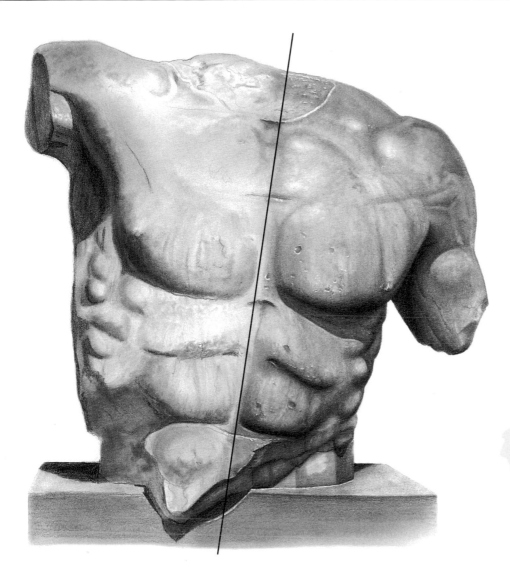

Finished Drawing (Well, Almost Finished)
Wow! What a difference the fine-tuning makes when you compare the improved right side to the original left. There's no limit to how realistic you can make your drawings if you have the right tools, practice, and, of course, a little time.

Pssssst!
Never let your brain convince you that you're not learning anything. Instead, outsmart your control panel by tracking your progress. You can do this simply by choosing a single image to draw at various points in the learning process. Be sure to pick something you like since you'll be drawing it over and over again! Once you've settled on an image, sit down and begin your first drawing. Don't tear it up whatever you do, even if it's awful. Just hide it somewhere and save it for later. When you come back to it two dozen drawings and several months later, you'll notice the marked improvement and quiet your fears.

Conclusion

Through the years, I've taken great delight in seeing the doubts of my students fade as they realize just how learnable drawing can be. I want to share a note with you from Greg Bean, one of my students and a contributing artist featured in this book:

> *"Carrie caught my attention when she stood up at the beginning of that first class and said, 'I am not here to teach you to draw, I'm here to teach you to see.' That seemed like a crazy thing to say to a room full of experienced detectives and police officers, but nothing could have been more true, or in my case, more profound. I was 39 years old, with more than fifteen years experience in law enforcement. Yet after that first week in class, I felt like I had been issued a brand-new pair of eyes—a much better pair. It literally added an entire new dimension to my life. I find beauty in almost every face I see, and in all sorts of other unexpected places. What an incredible gift! Learning to draw takes some work, but it is infinitely worth the trouble! I can't even explain how much I love to draw."*

Whether you choose to draw just for your own enjoyment or to share and sell your work, rest assured—you can draw. Learning to draw can also mark the start of your artistic journey. Drawing skills open the door to a variety of different applications: oils, watercolors, pastel pencils and so on. Push on, my friend, toward your artistic goal. Remember what the great philosopher Lao-tzu wrote: "The journey of a thousand miles begins with a single step."

Almost Too Real for Reality
A slide of this drawing was sent to an art show and rejected due to "bad photography." What the show organizers didn't realize is that the taped edges and tag are actually part of the drawing! Now *that's* realism.

THE ILLUSION OF A YARD SALE PHOTOGRAPH
Matt Tucker
Graphite on 300-lb. (640gsm) cold-pressed illustration board
24" x 18" (61cm x 46cm)

INDEX

Learn to draw and paint like the pros
with these other fine North Light Books!

Drawing Realistic Pets From Photographs
by Lee Hammond
ISBN 1-58180-640-X, PAPERBACK, 128 PAGES, #33226

Everyone has photographs of their favorite pets, and now you can use bestselling author Lee Hammond's mastery of the subject to capture them as art. Learn all the basics of drawing your pet accurately from a photograph using the step-by-step directions, break down of animal features and ideas for backgrounds that will really bring your drawings to life.

Drawing People by Barbara Bradley
ISBN 1-58180-359-1, HARDCOVER, 176 PAGES, #32327

Are you looking for a complete course in drawing the clothed figure? Learn the tricks behind the folds and draperies of clothing and the proportion, perspective and values you need to portray them accurately. With approximately 700 black and white illustrations, this book can teach you everything you need to know.

No Experience Required: Drawing and Painting Animals by Cathy Johnson
ISBN 1-58180-607-8, PAPERBACK, 112 PAGES, #33165

The six demonstrations and many exercises in this book will have you seeing immediate improvement in your work. Covering many popular mediums including watercolor, pencil and pen and ink, as well as all your favorite animals, this book has something for everyone looking to fine-tune their animal drawings. Try it today!

Painting with Brenda Harris, Volume 2: Precious Times by Brenda Harris
ISBN 1-58180-698-1, PAPERBACK, 112 PAGES, #33357

Follow popular PBS instructor Brenda Harris through thirteen easy-to-follow paintings in acrylic! With patterns supplied for each project and Brenda's warm encouragement, you will complete a beautiful painting in just a few hours.

Secrets to Drawing Realistic Faces by Carrie Stuart Parks
ISBN 1-58180-216-1, PAPERBACK, 144 PAGES, #31995

Learn how to realistically depict the faces of your friends and family! Award winning forensic artist and teacher Carrie Stuart Parks teaches you how to master proportions, map facial features, draw shapes and bring values to life. Follow her clear step-by-step instruction to more convincing faces.

These books and other fine North Light titles are available at your local fine art retailer or bookstore or from online suppliers.